Butterflies & Birds

Adult Coloring Book

By

Lamees Alhassar

the copyright ©2019 Lamees Alhassar

All rights reserved.

ISBN: 9781693309427

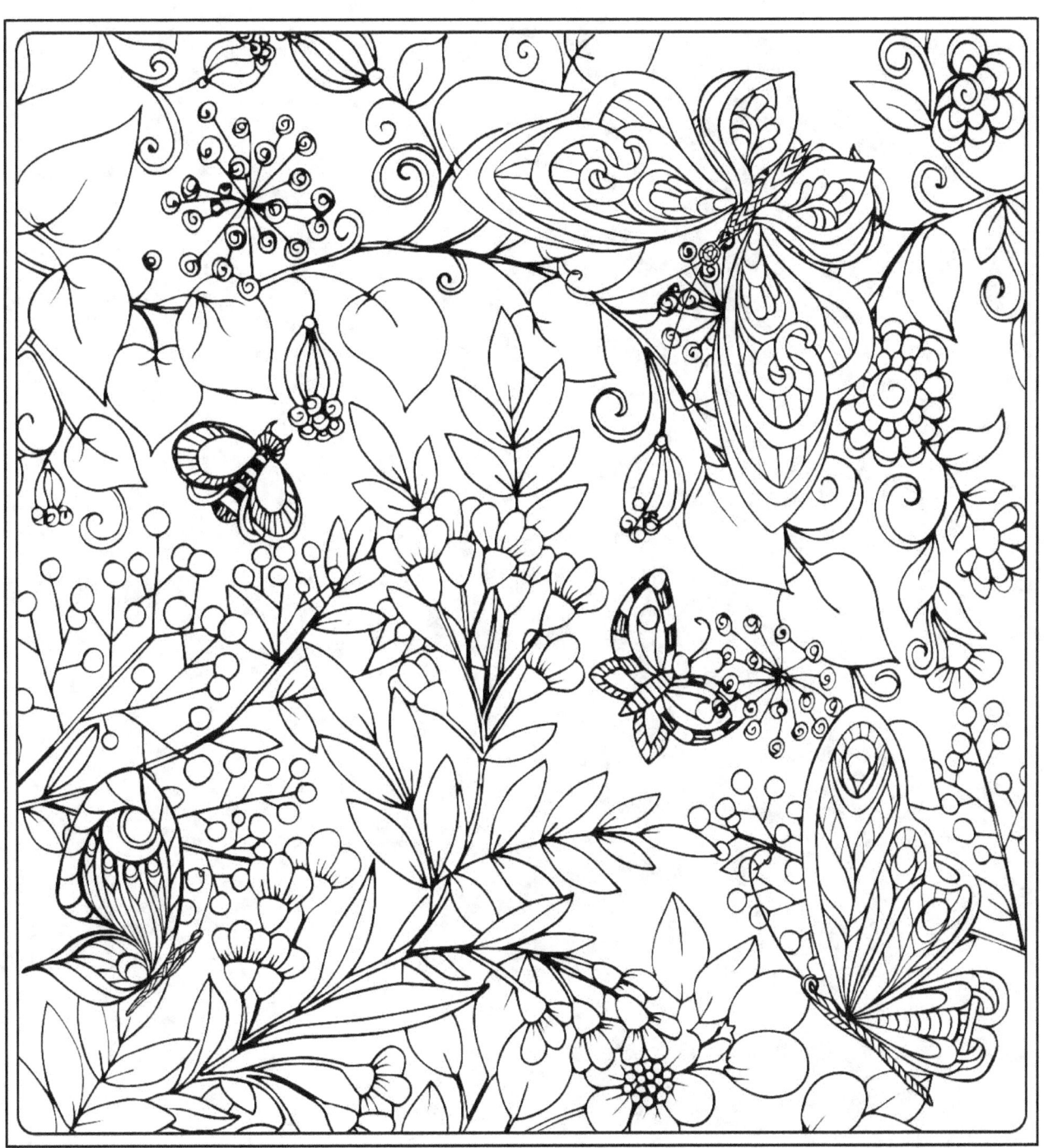

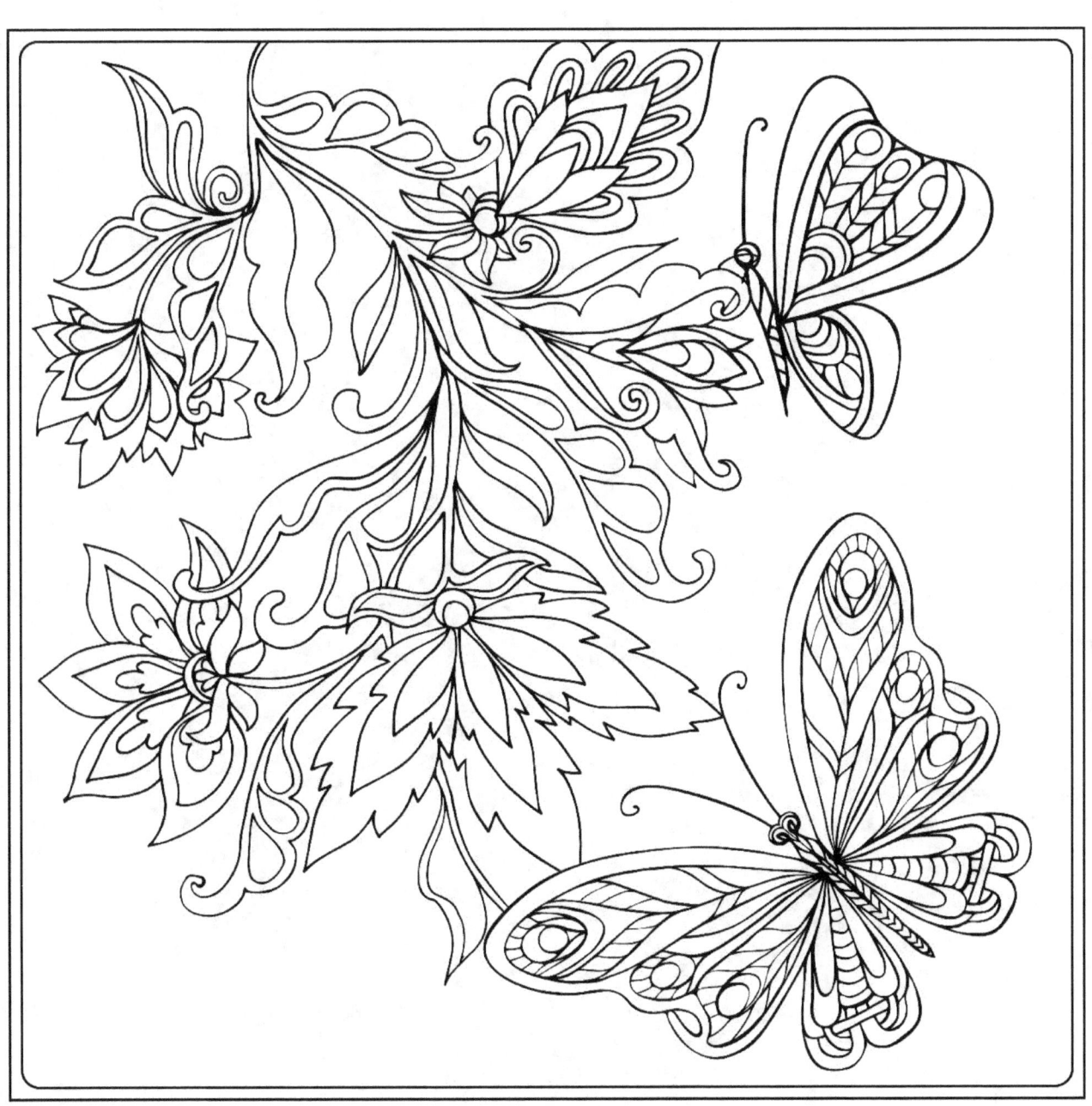

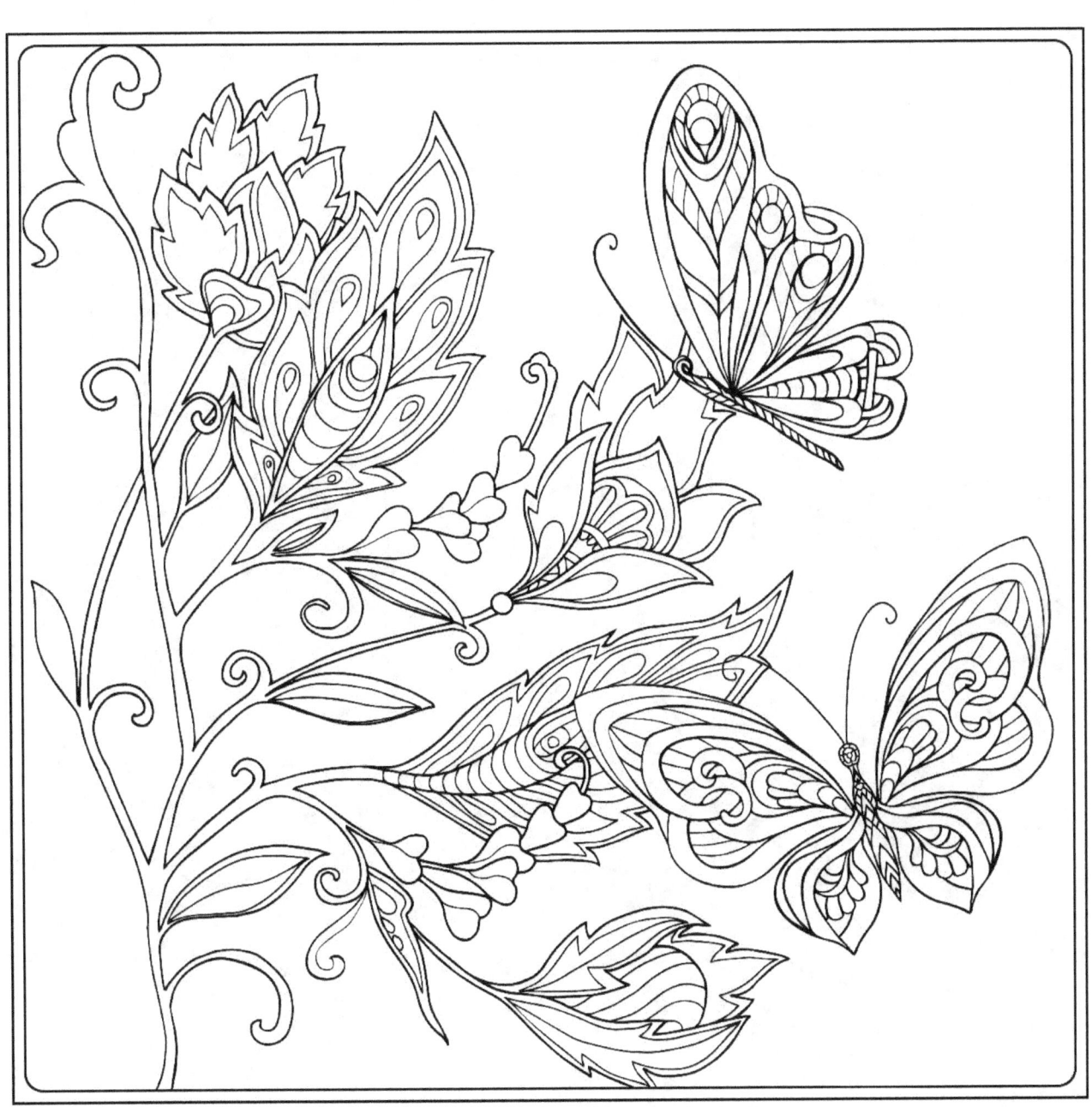

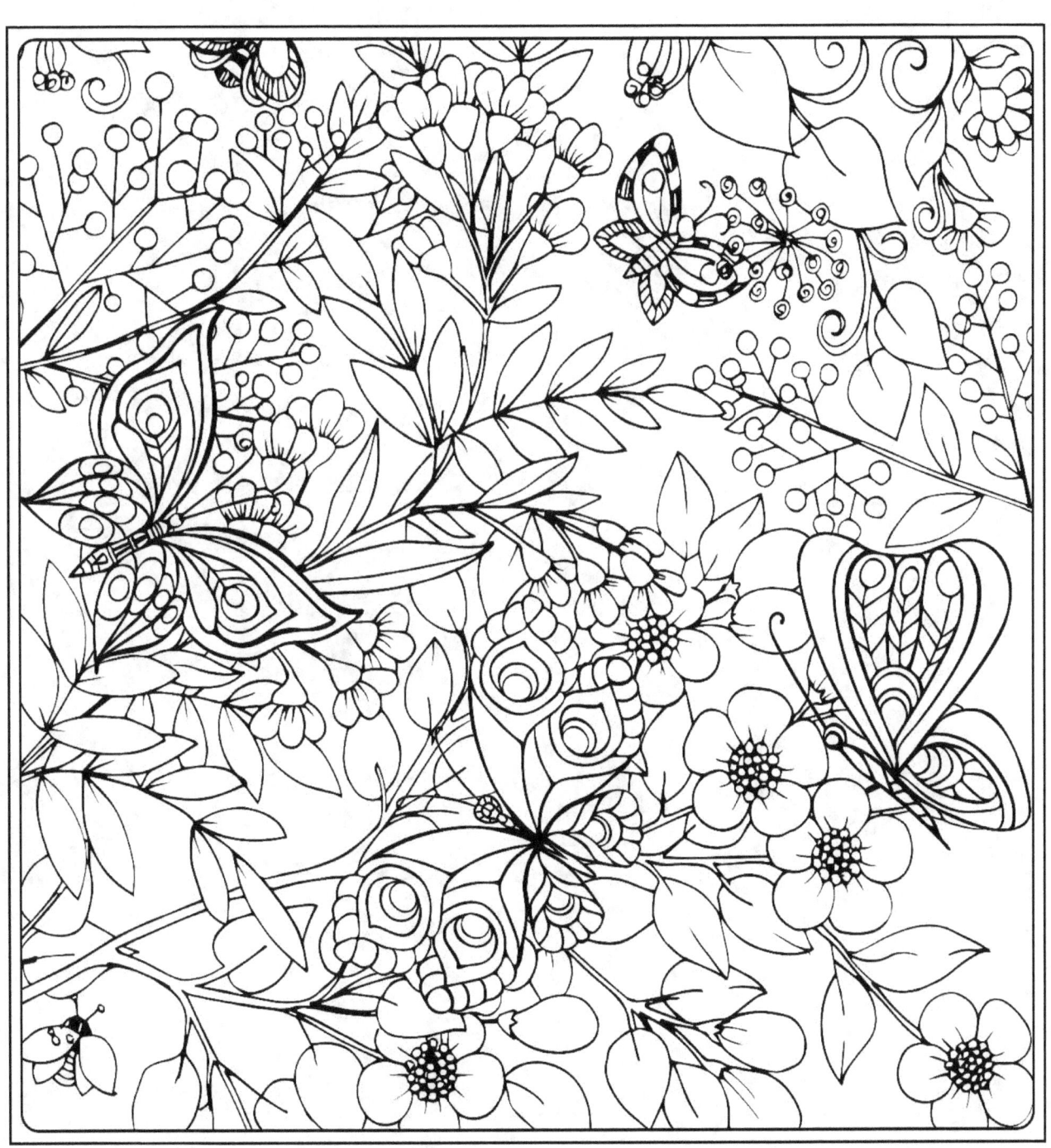

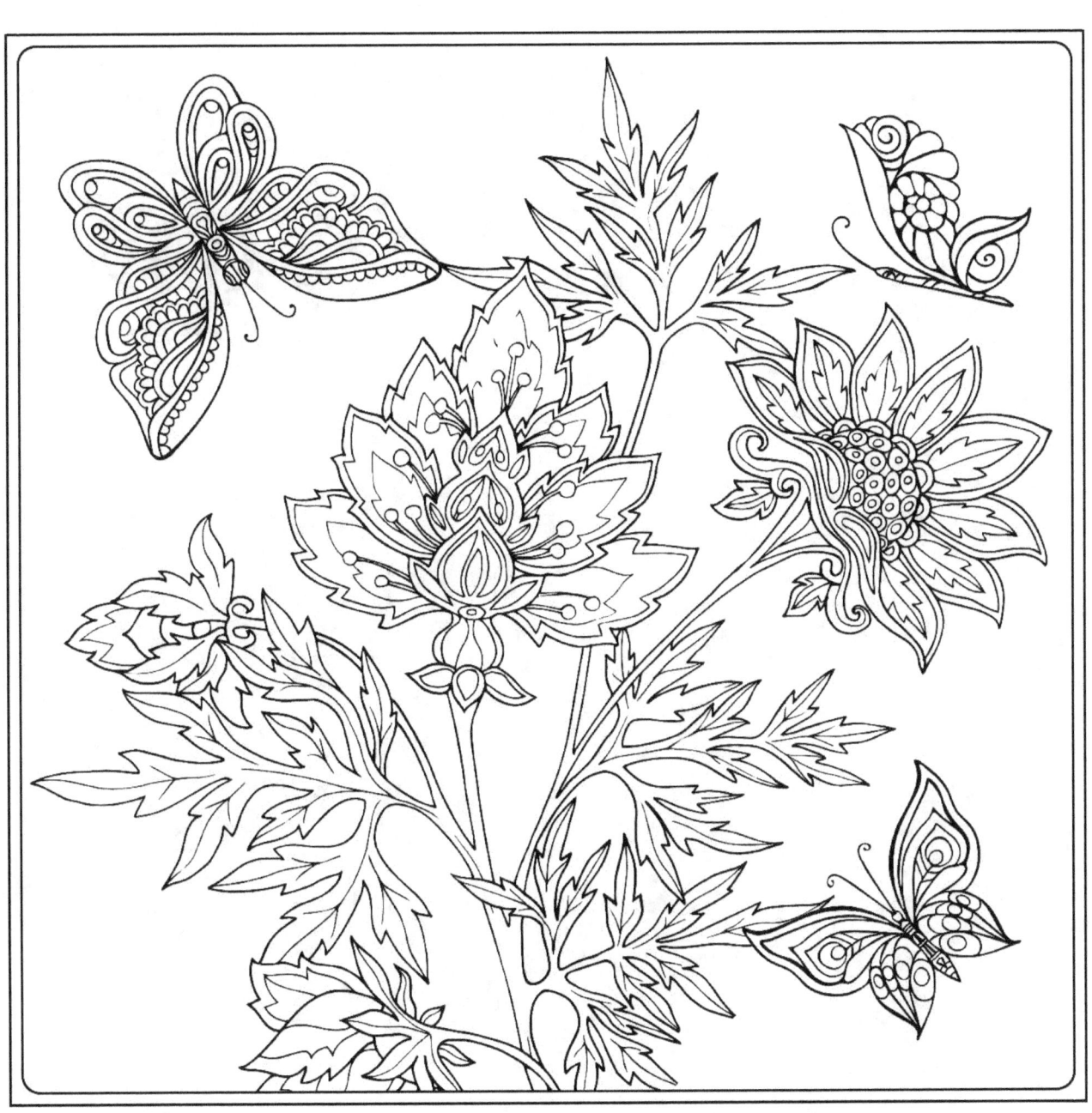

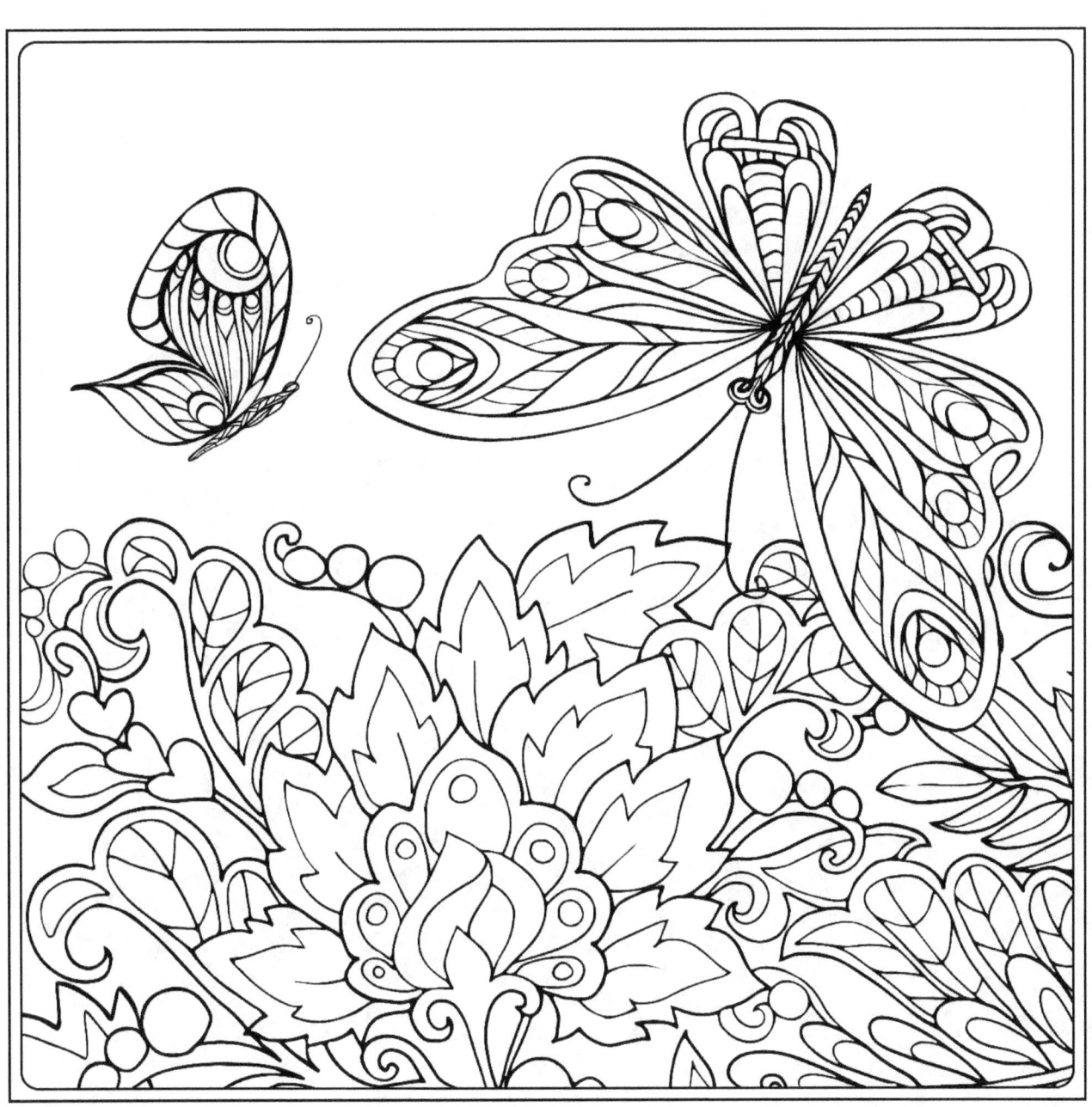

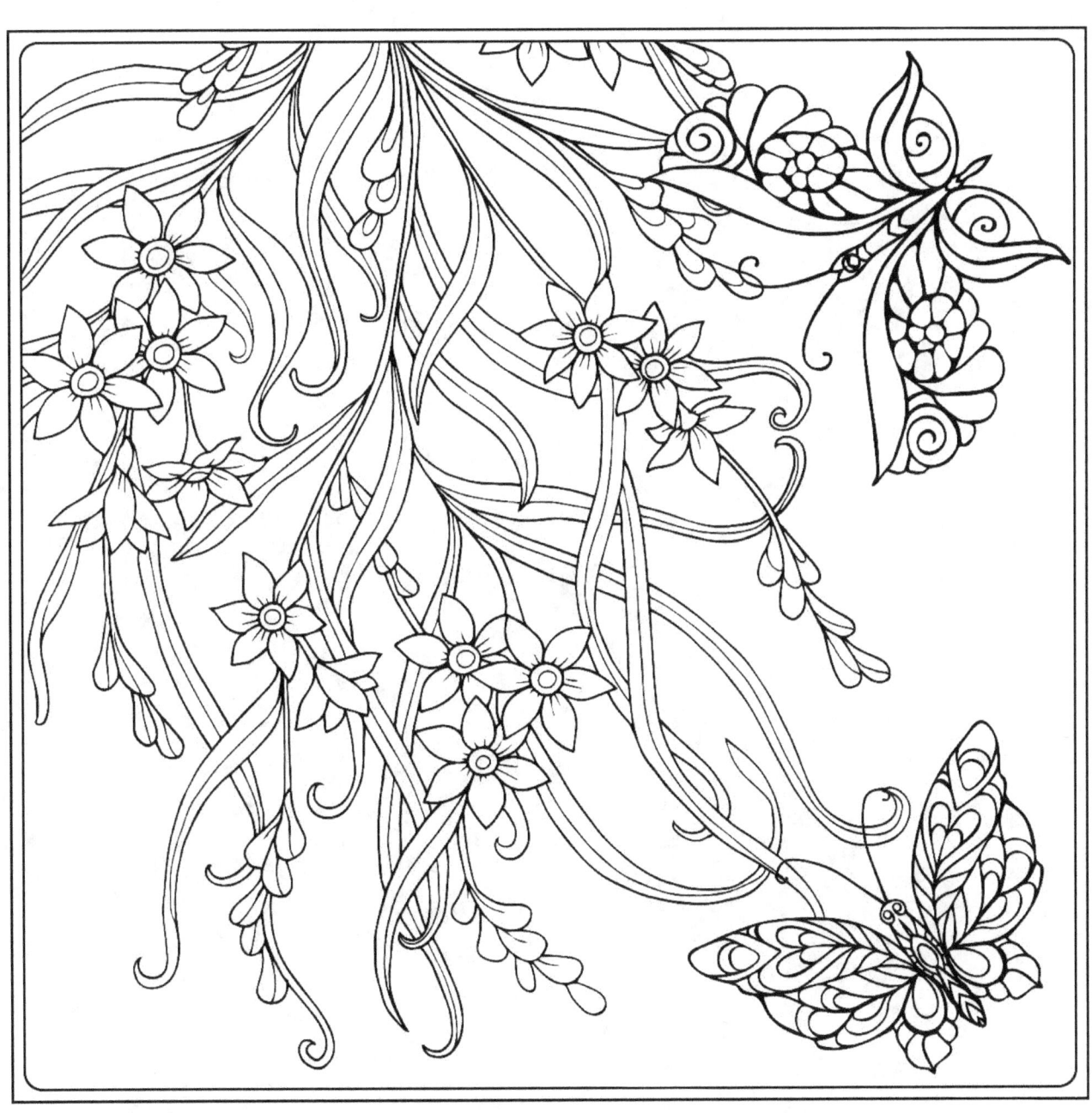

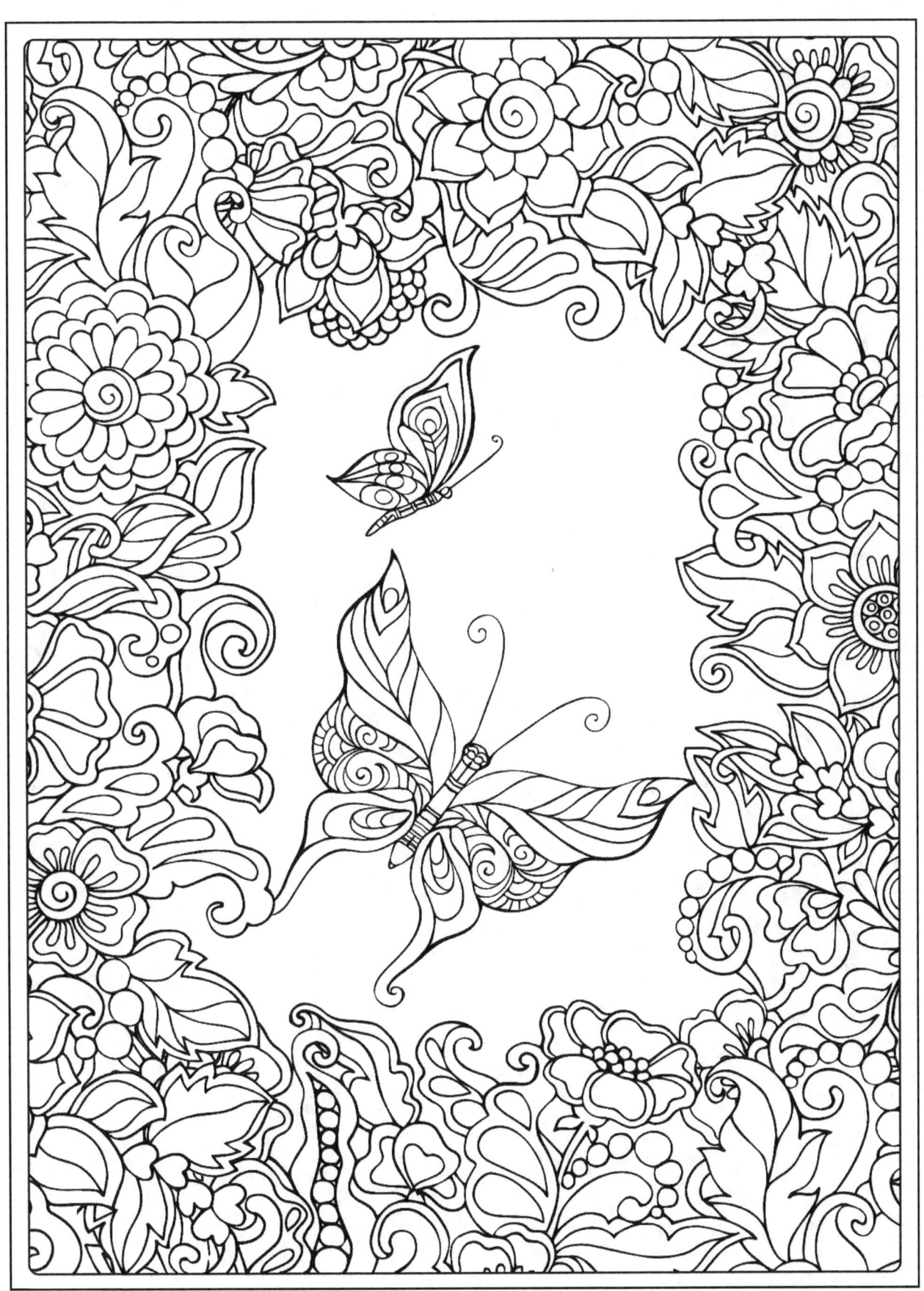

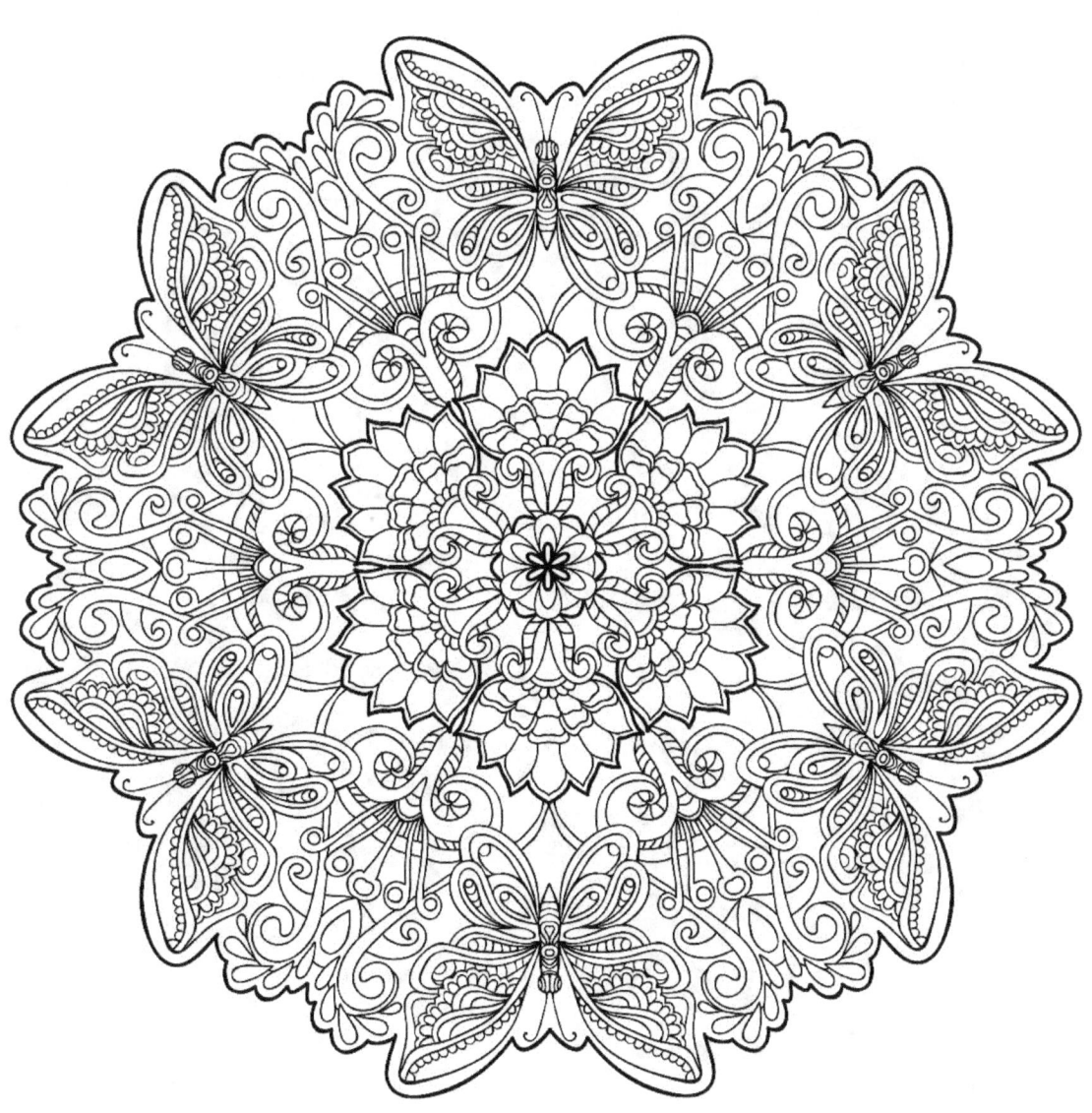

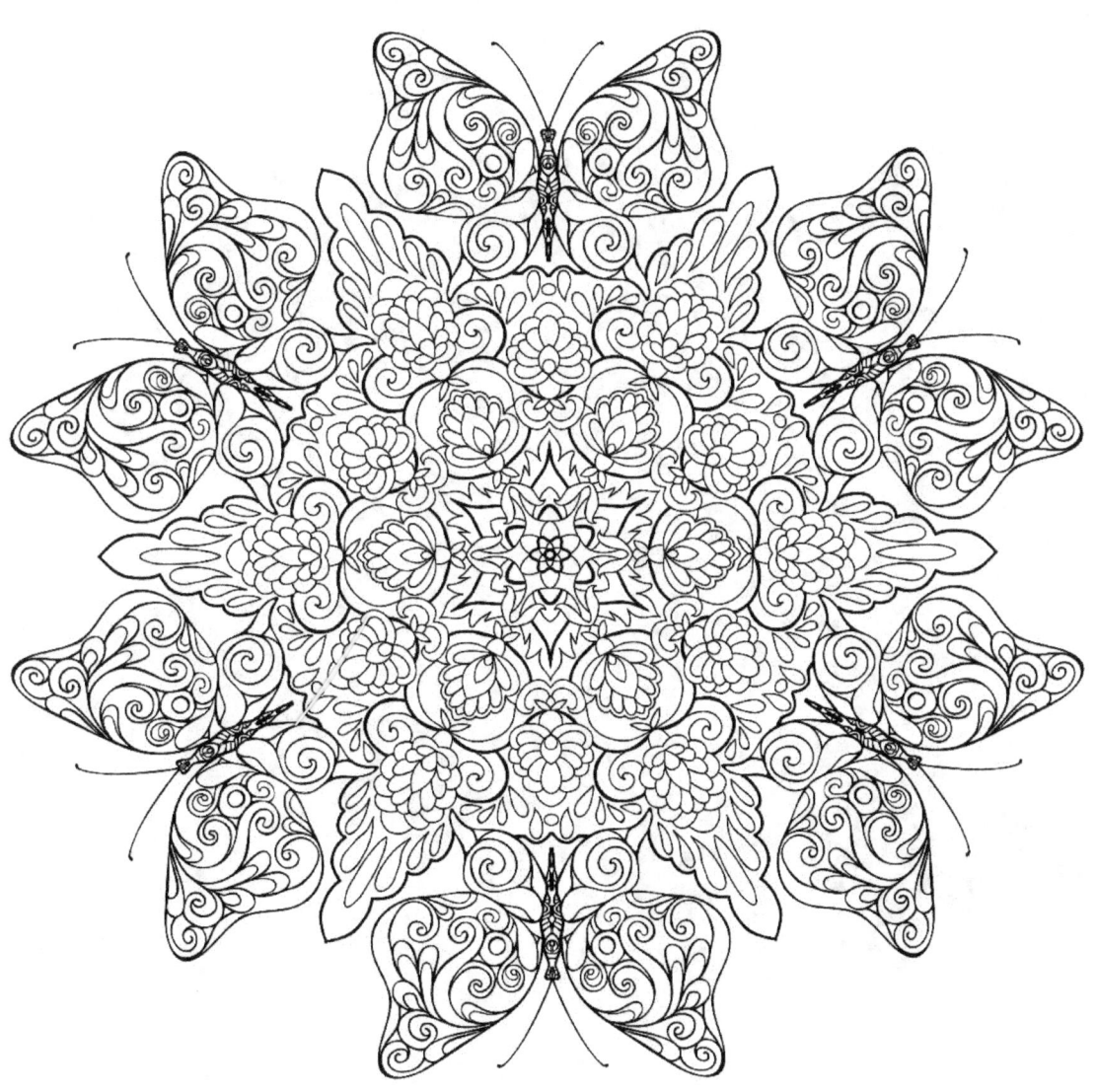

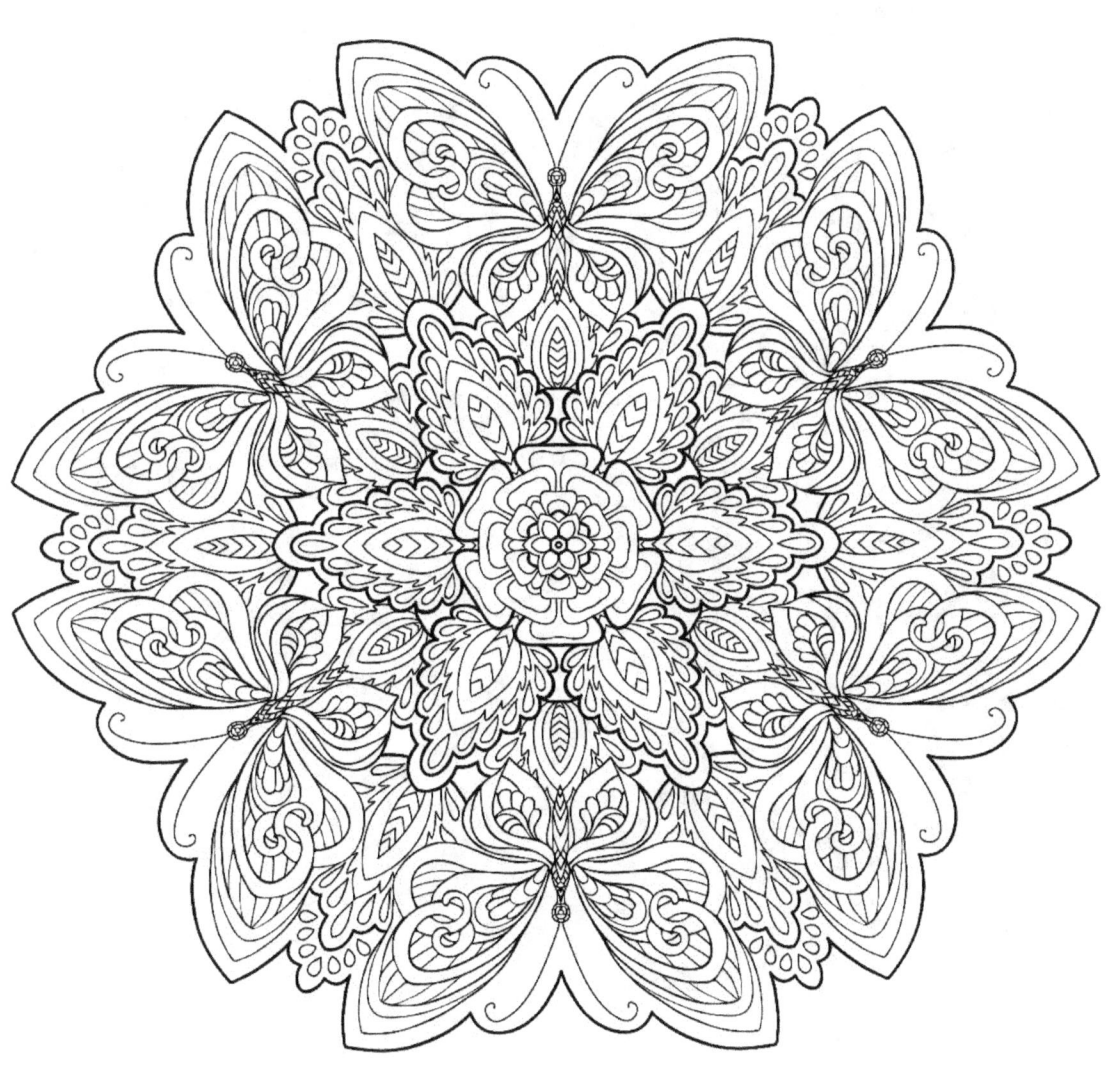

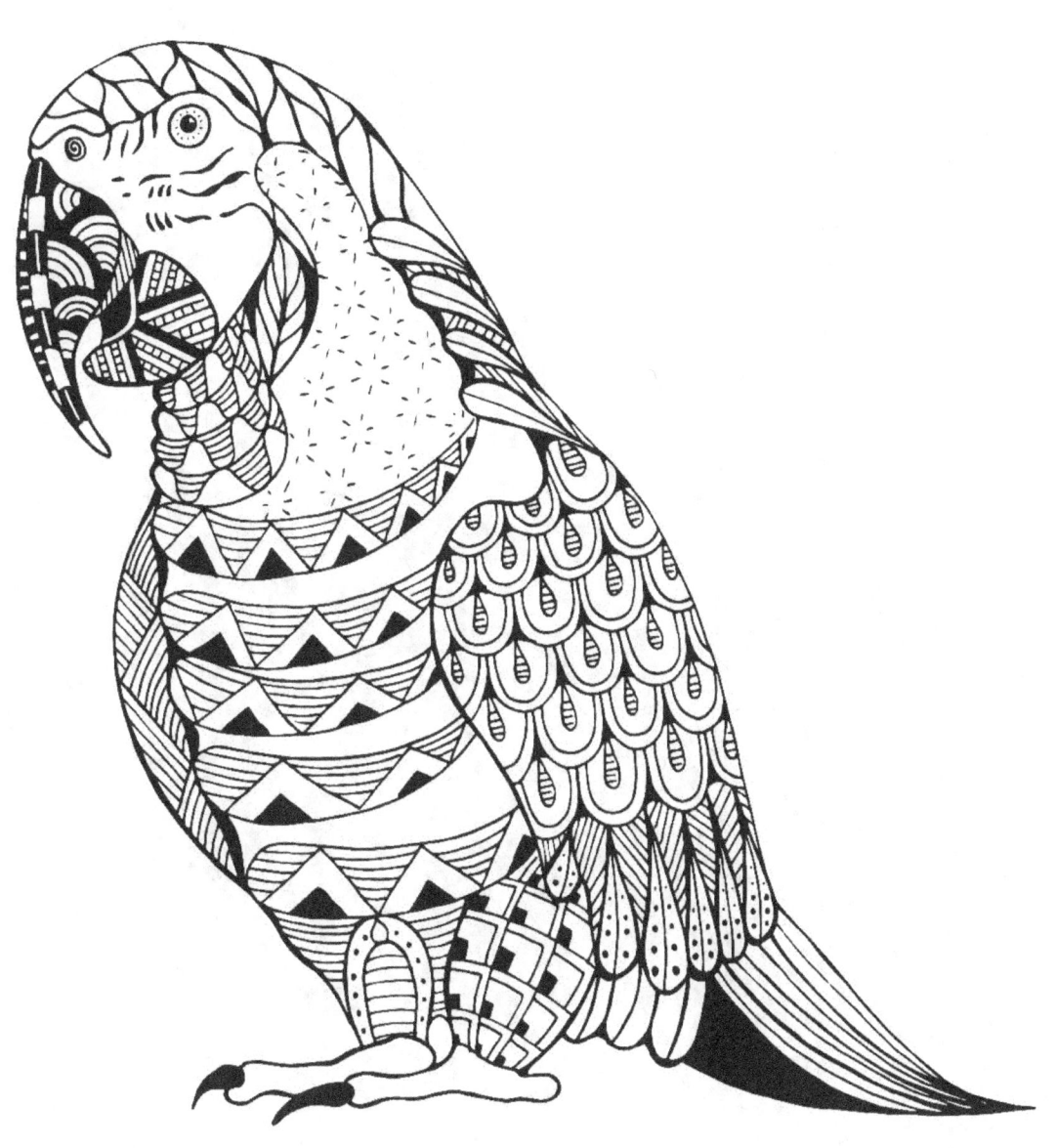

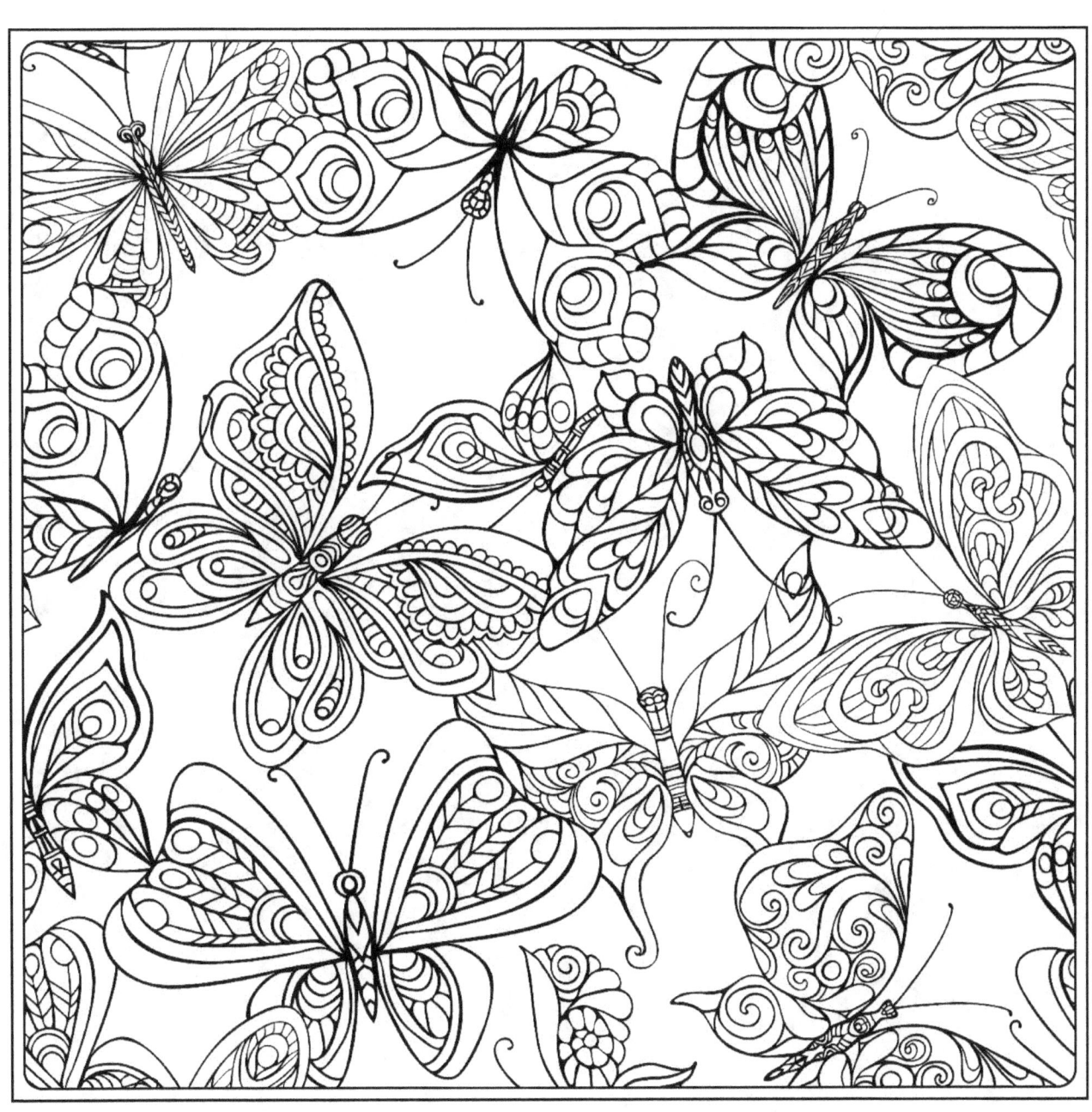

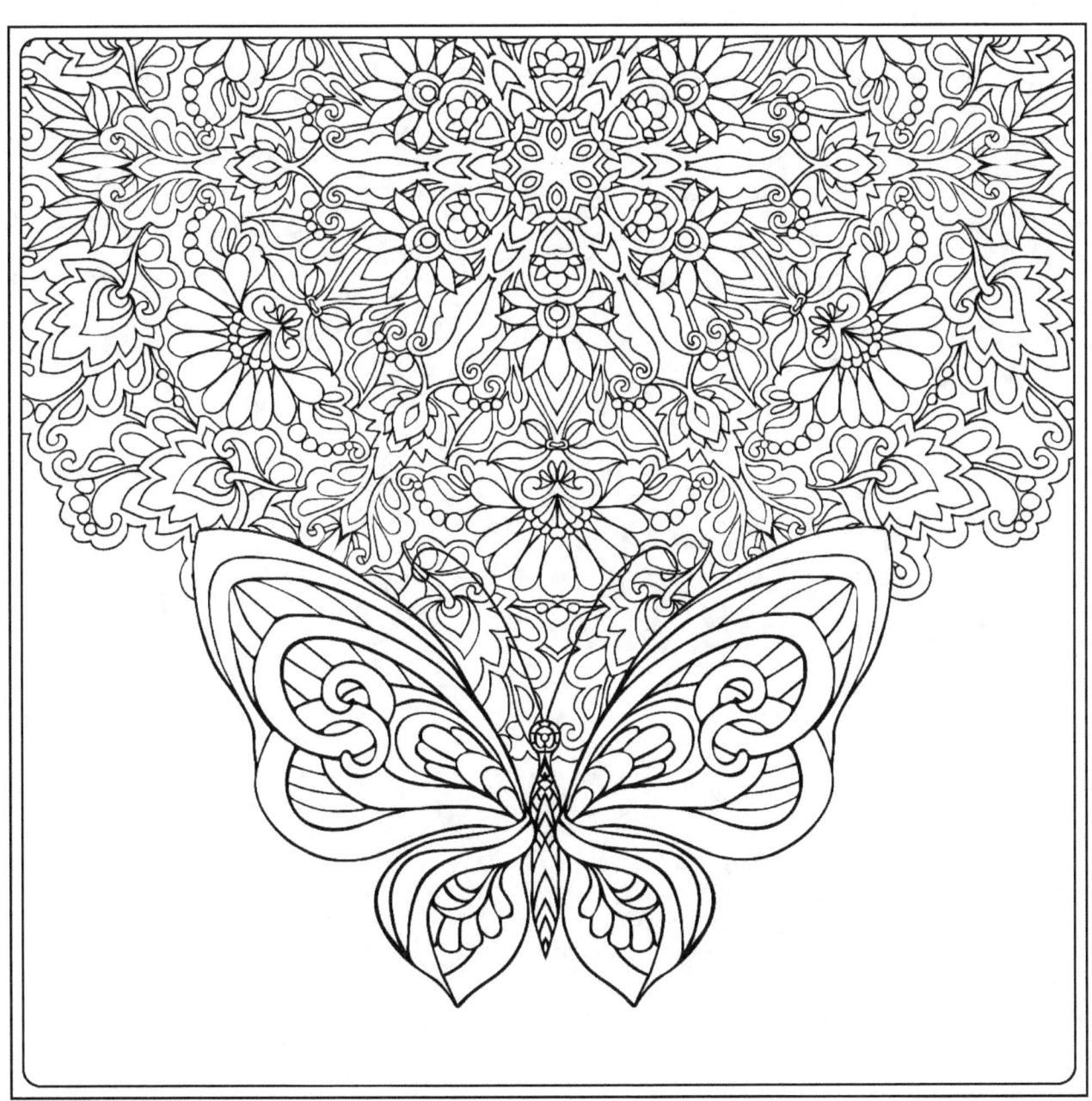

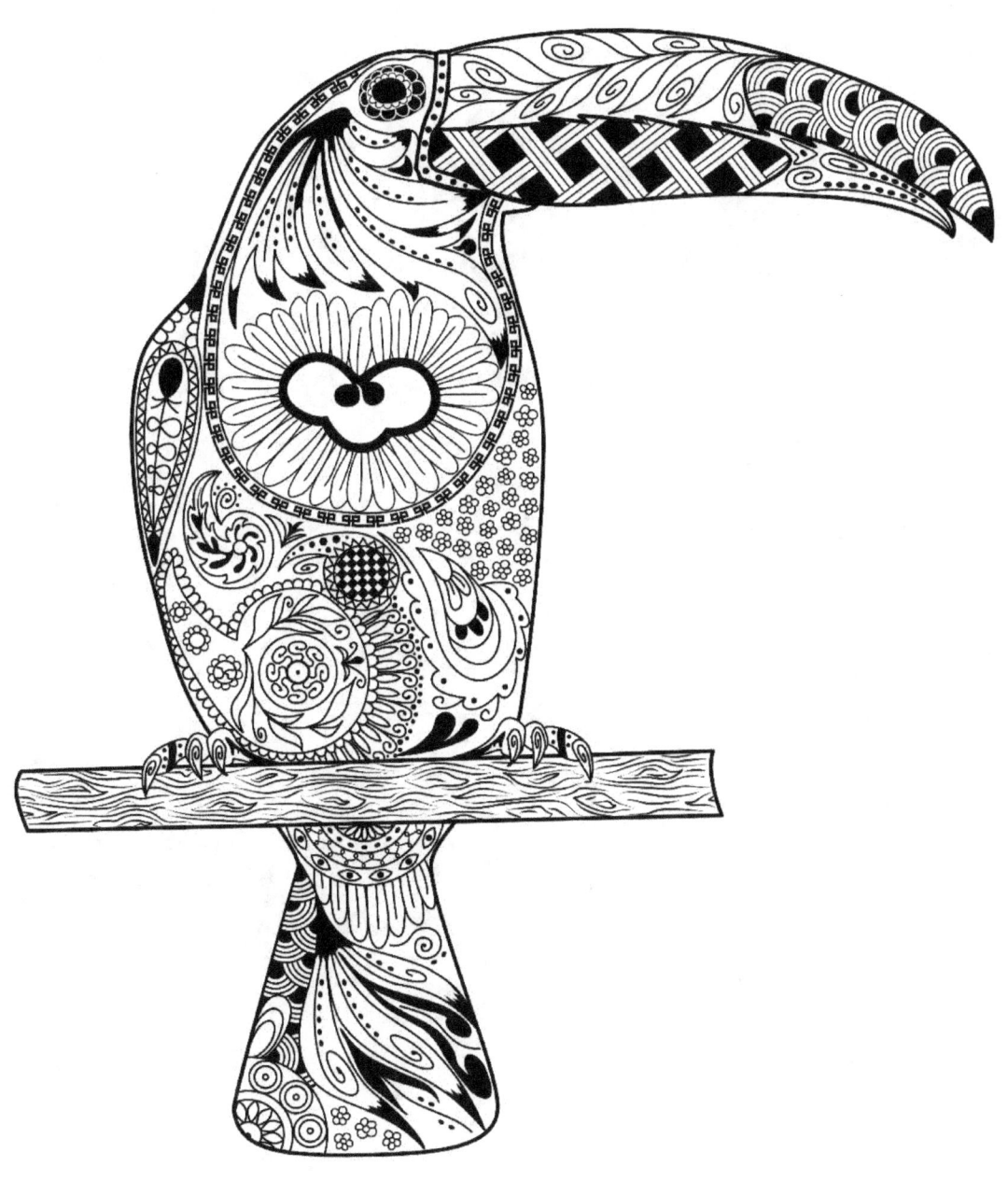

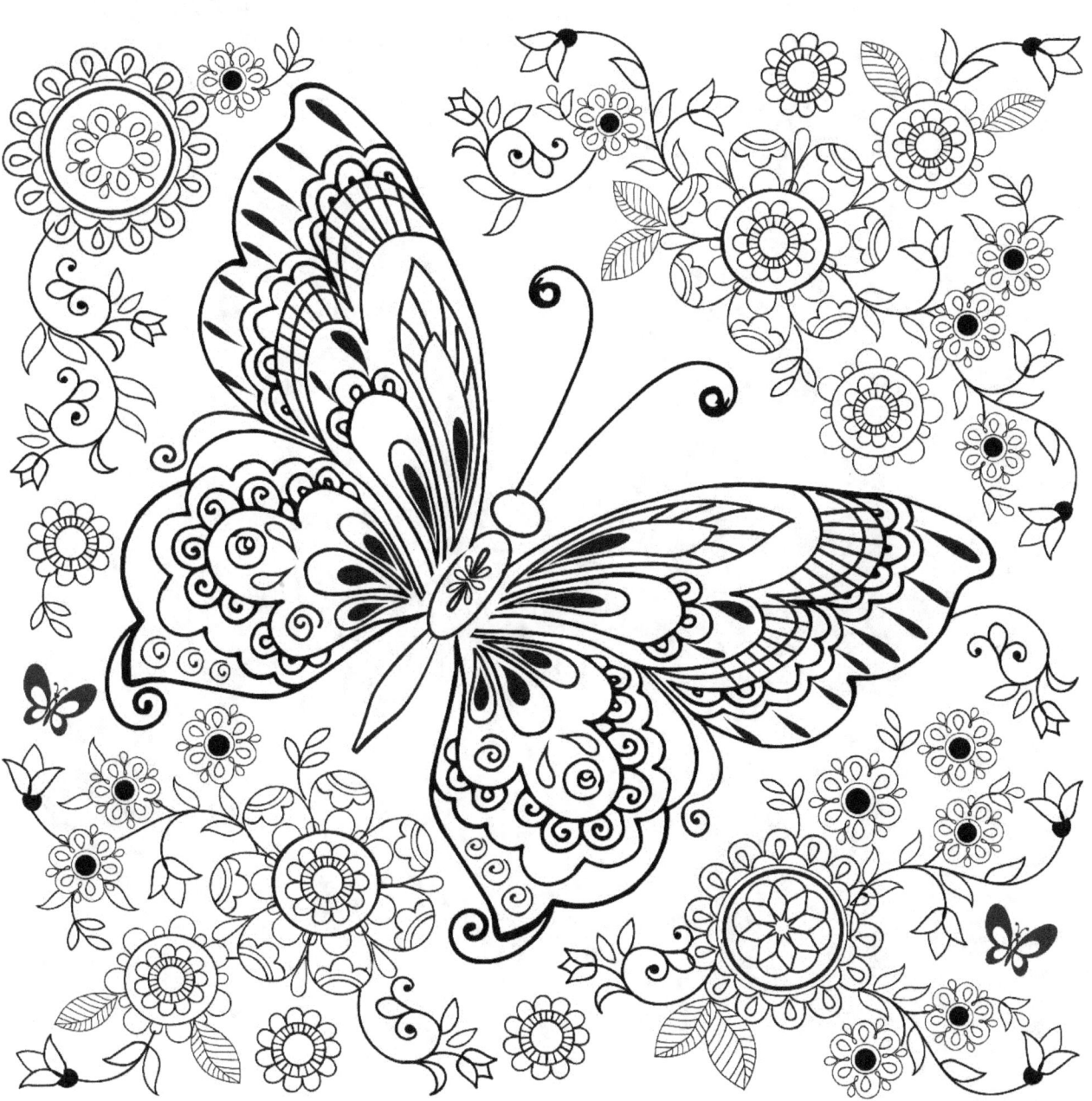

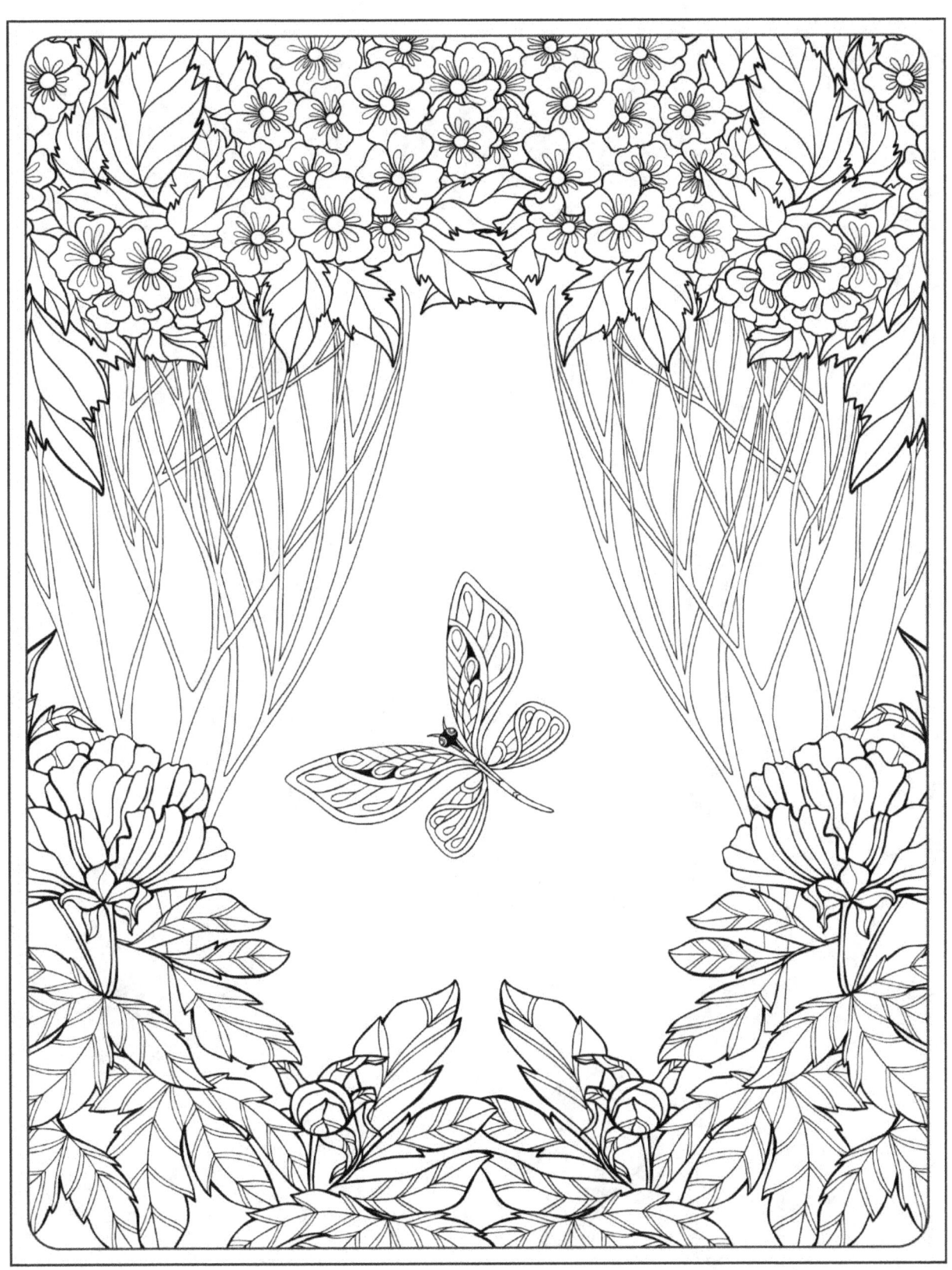

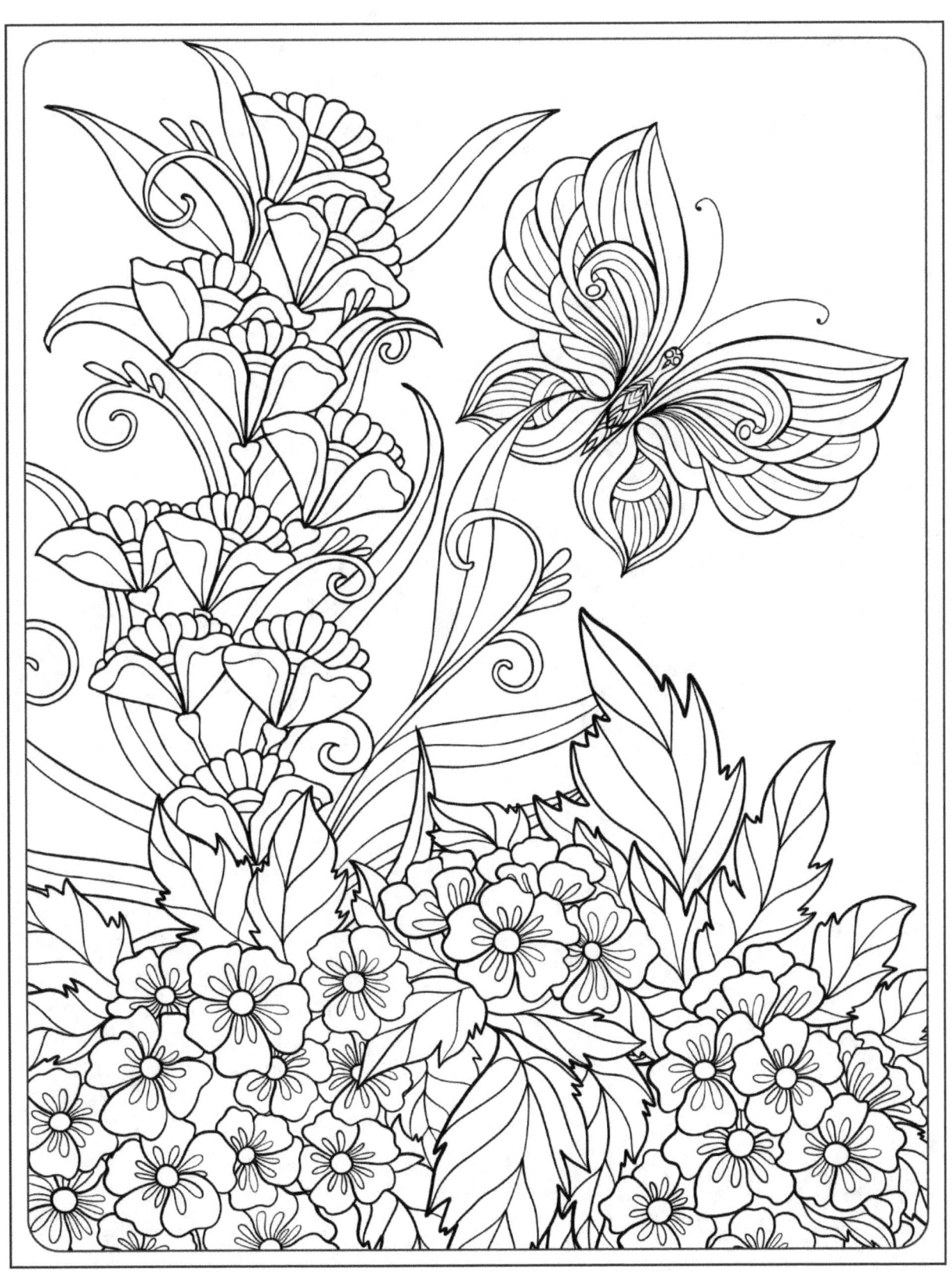

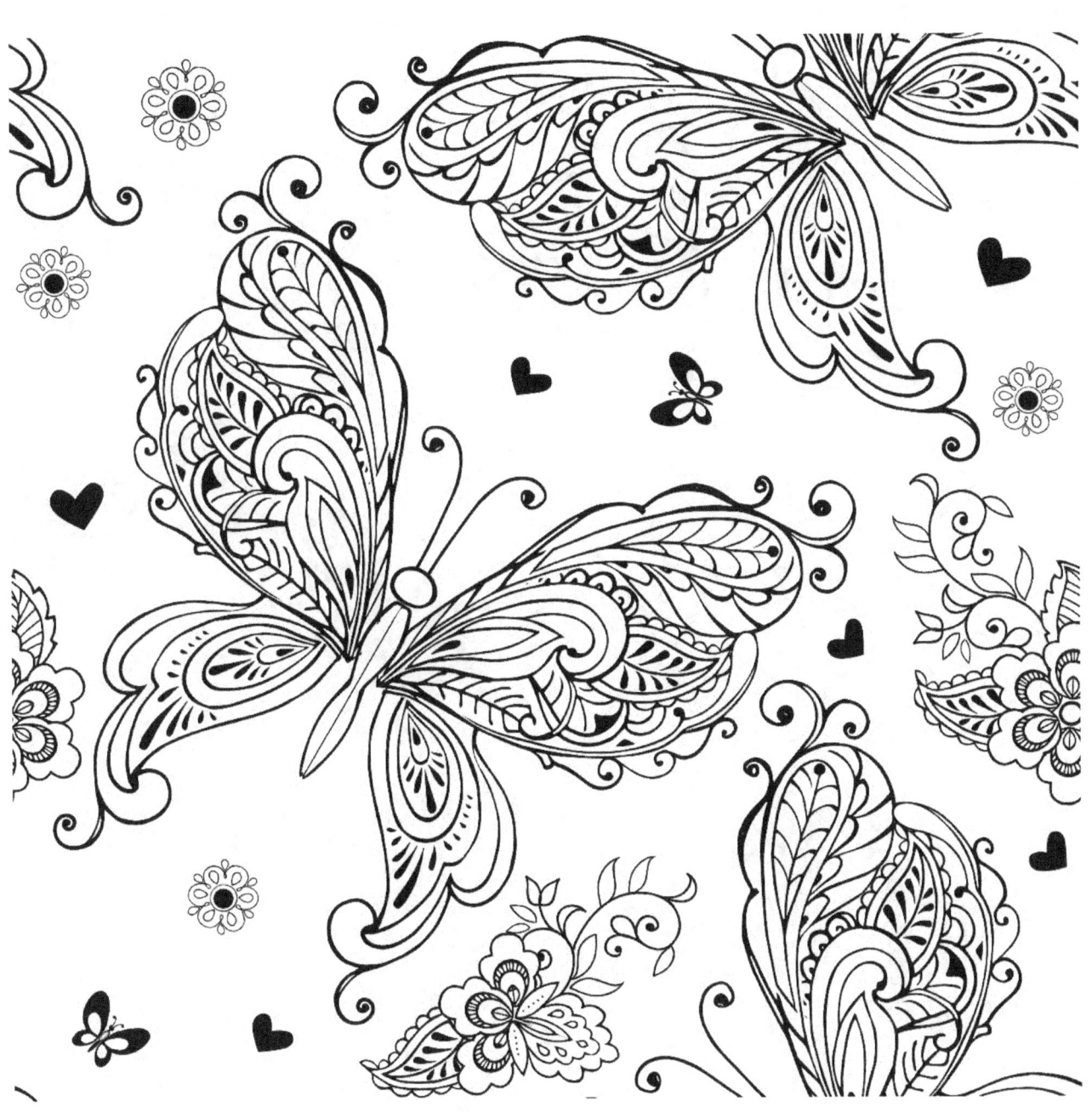

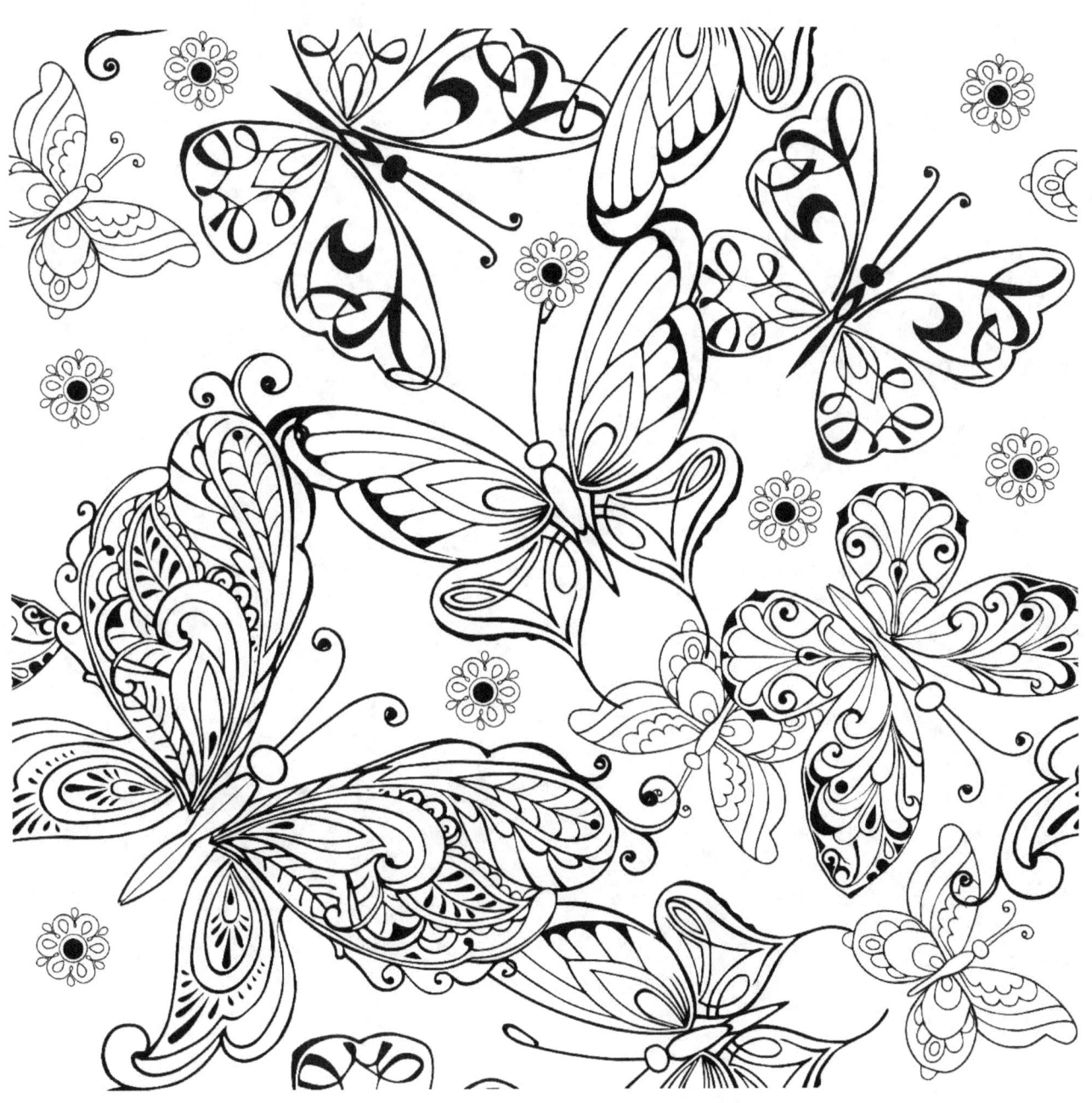

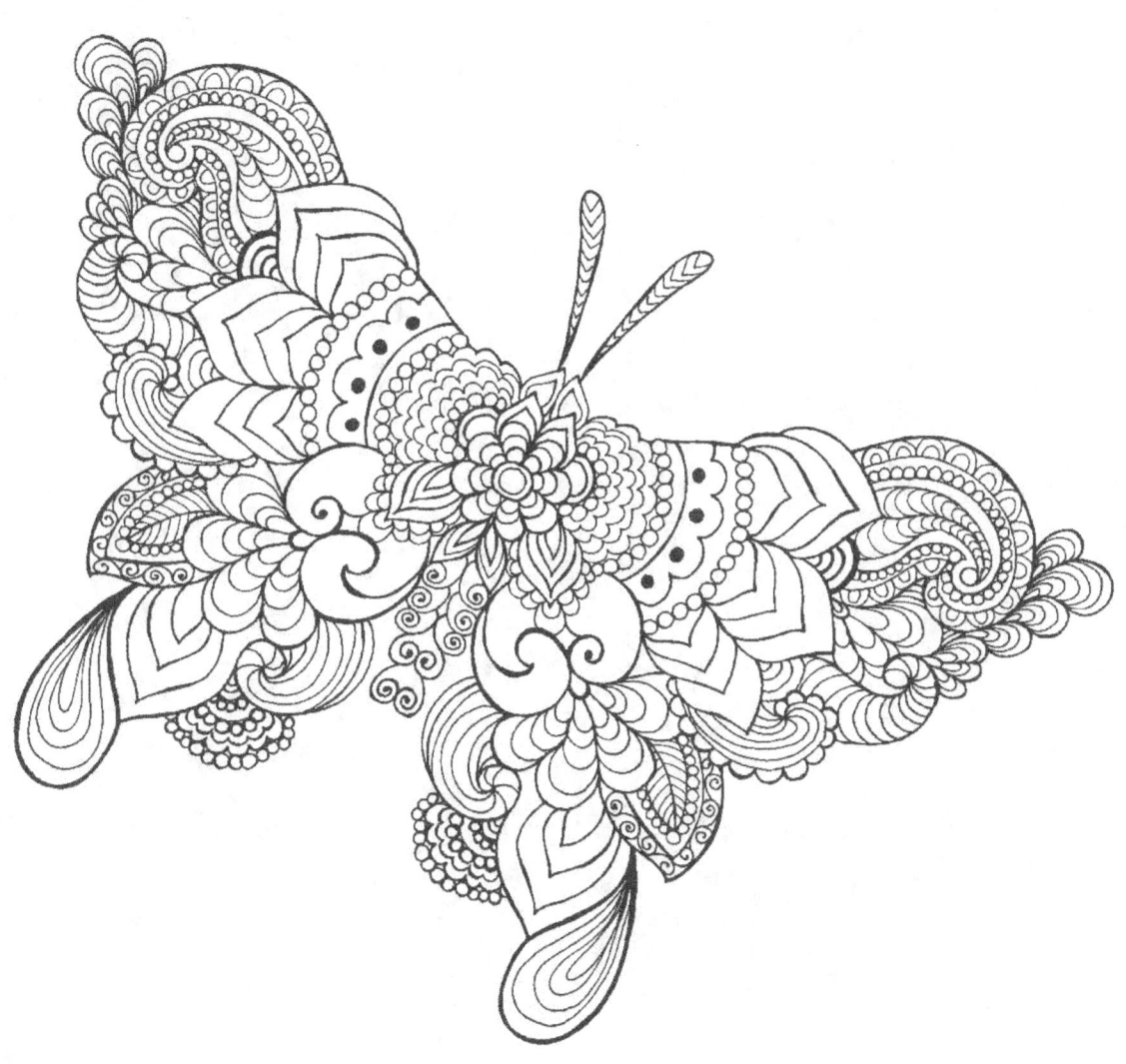

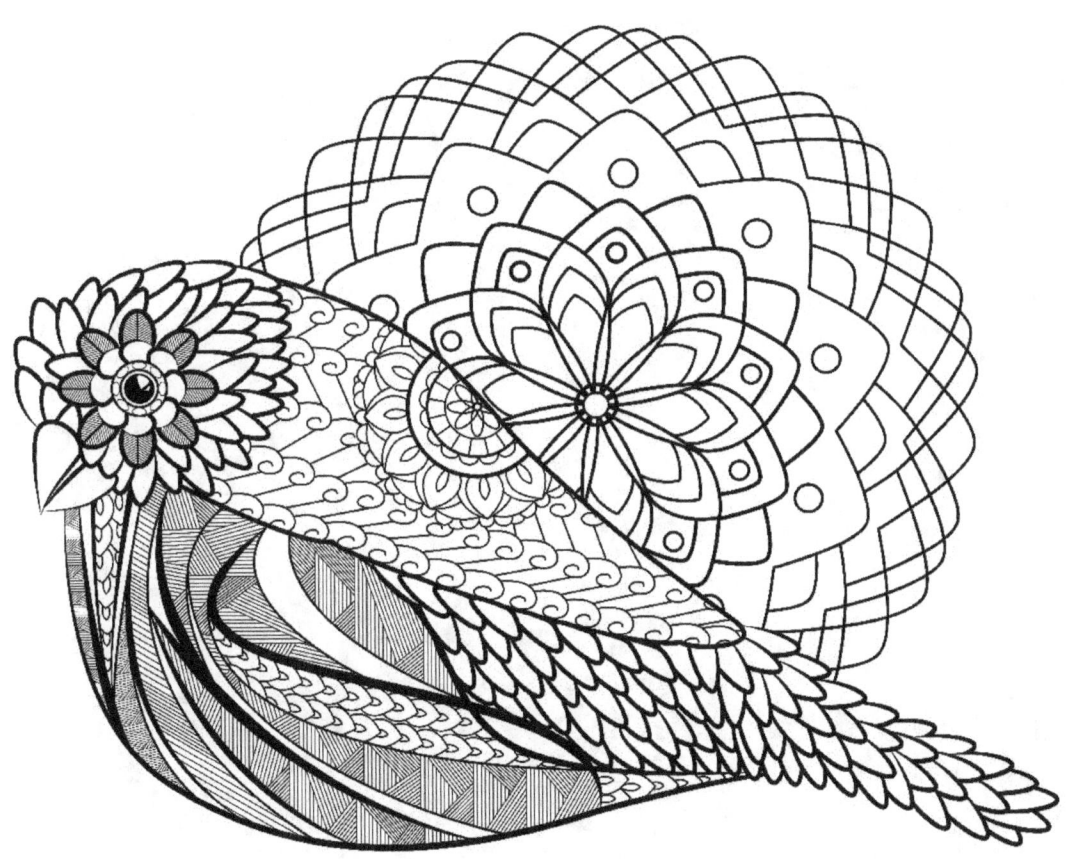

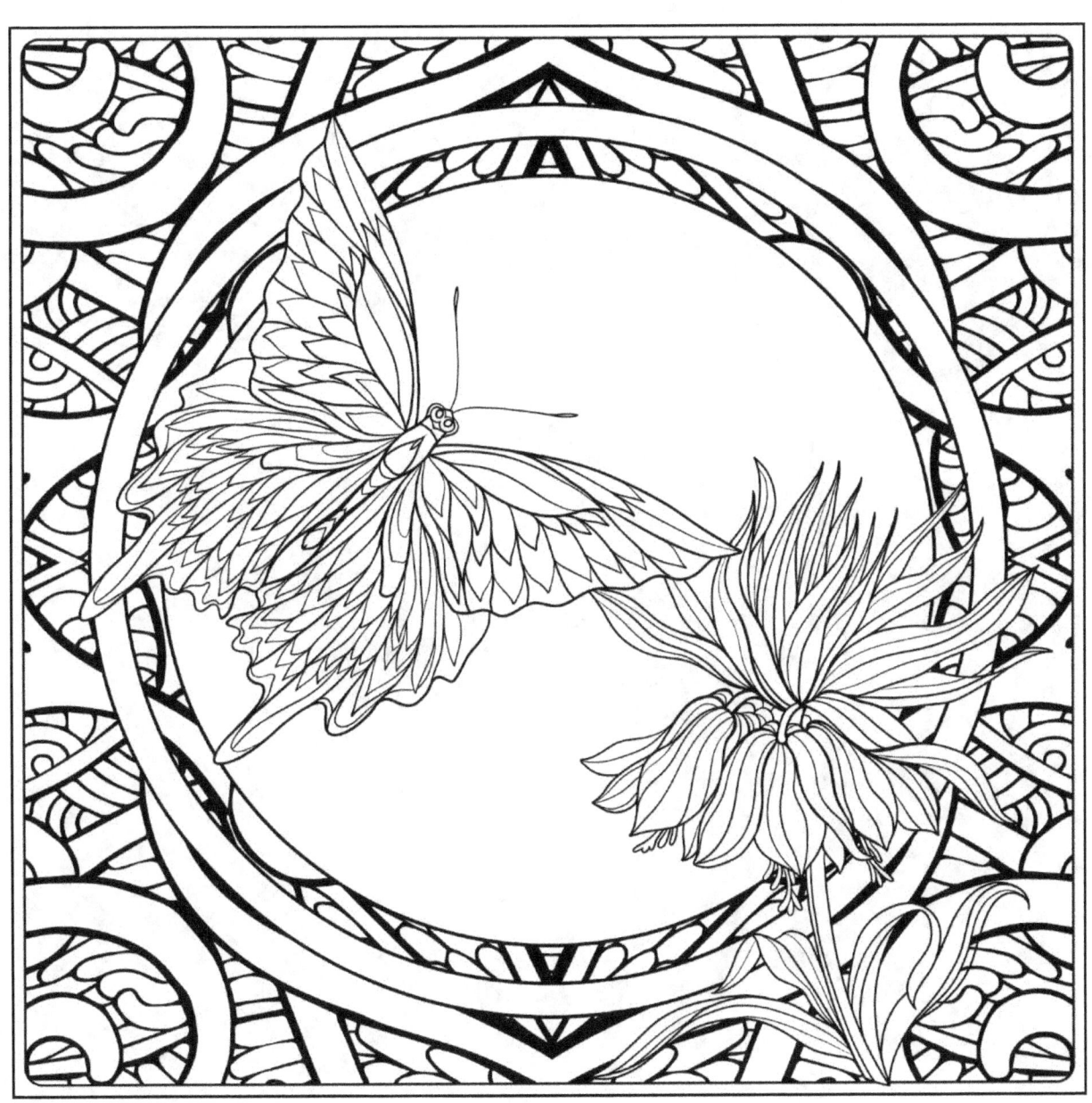

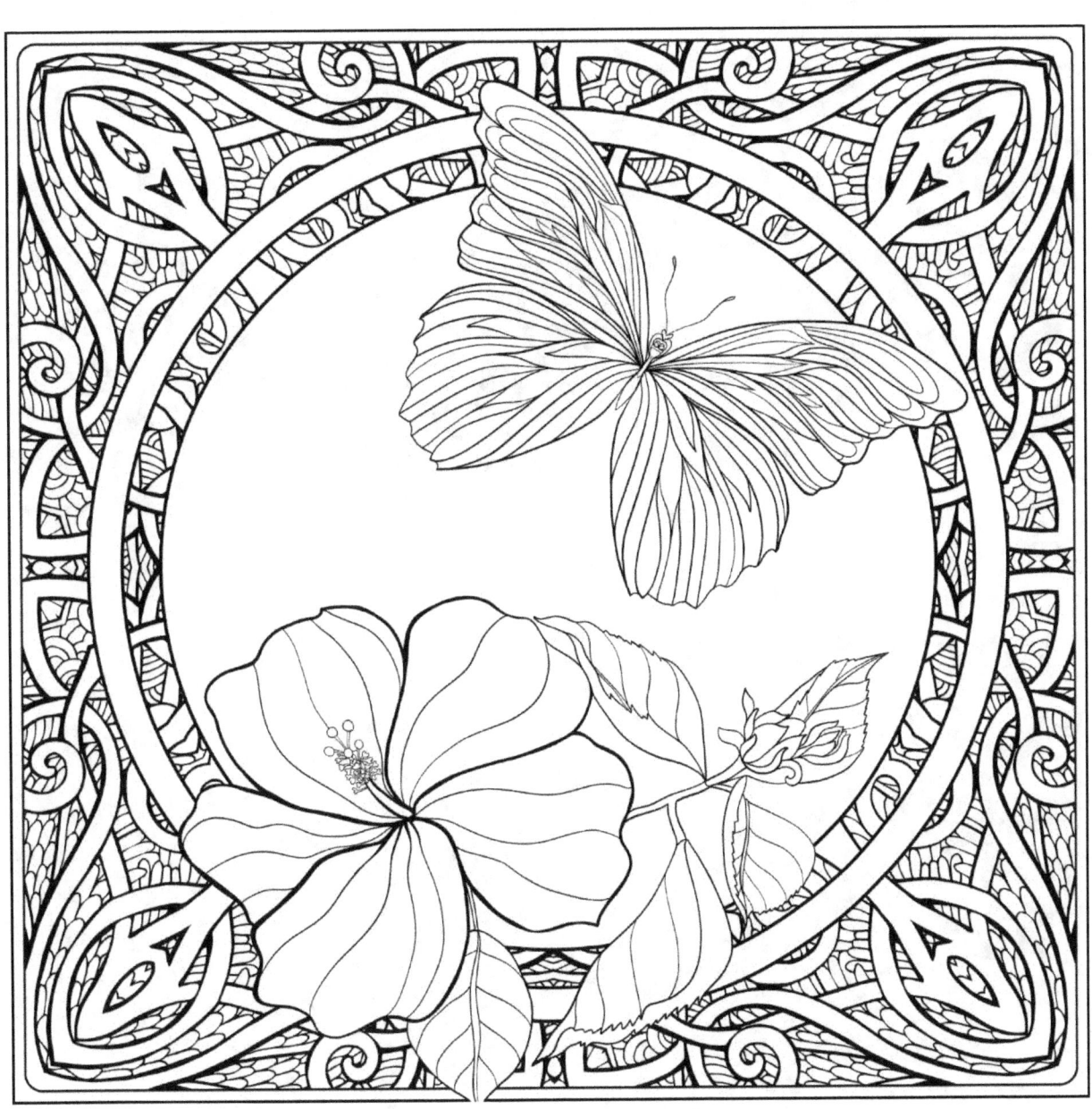

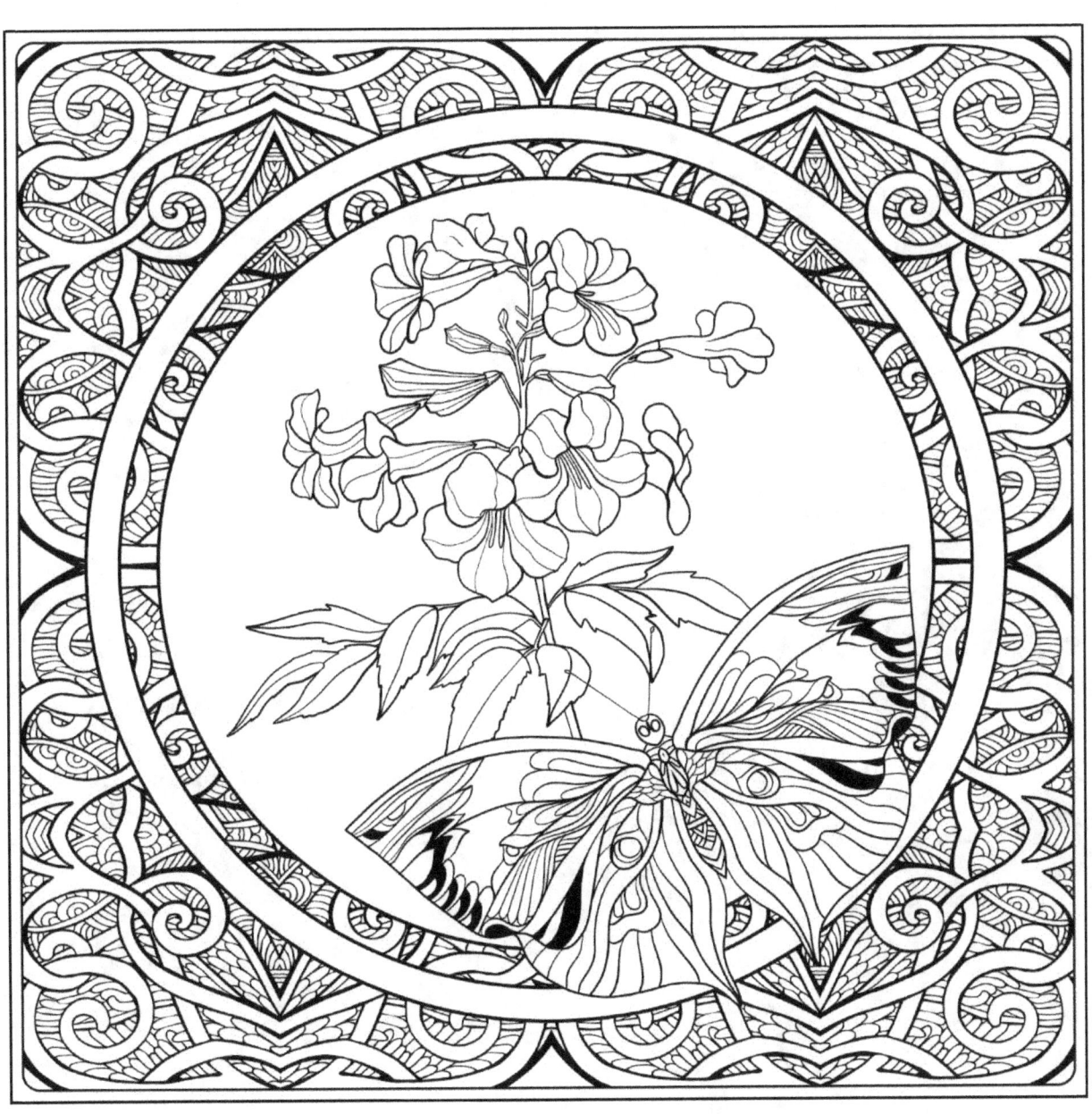

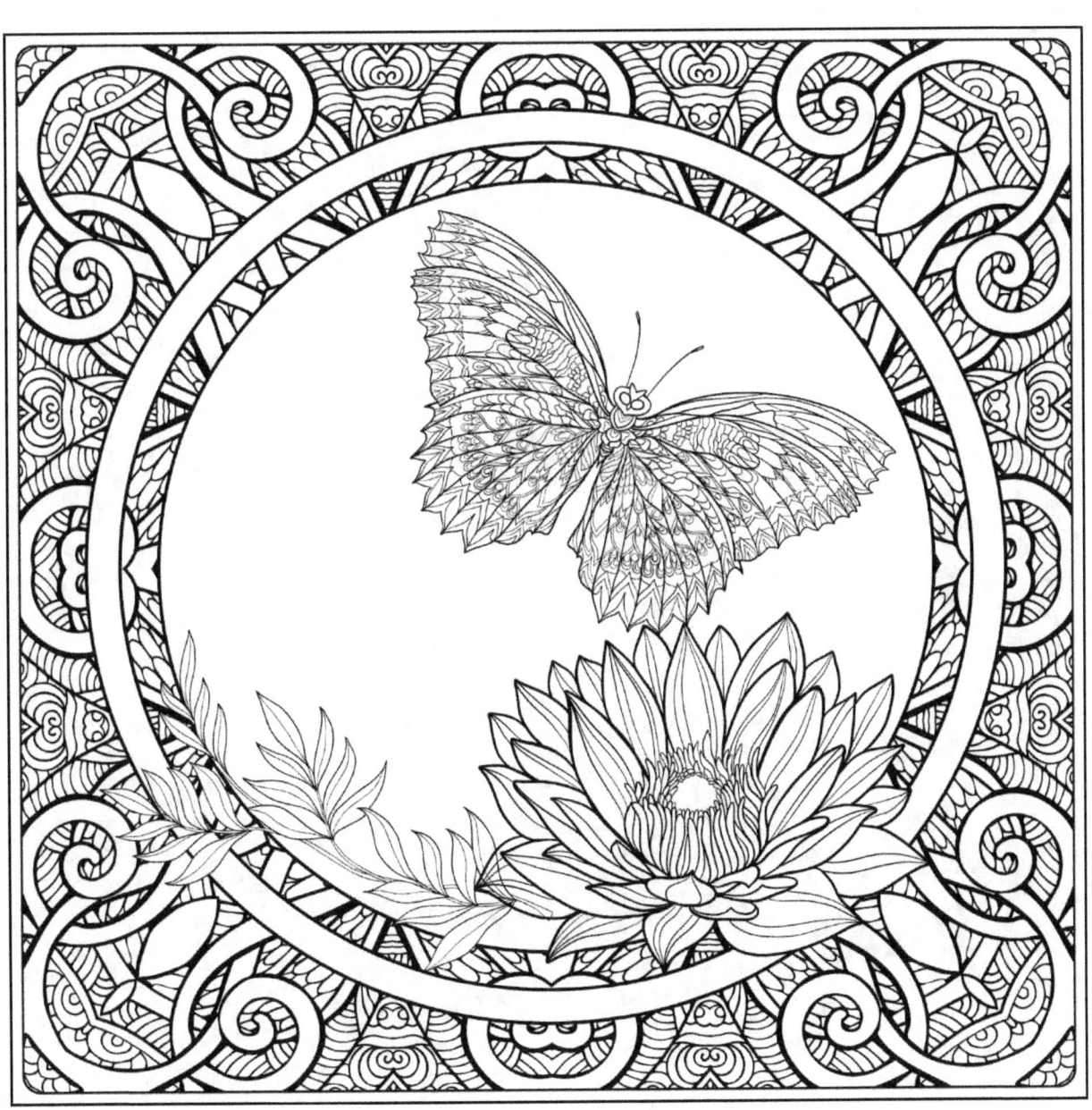

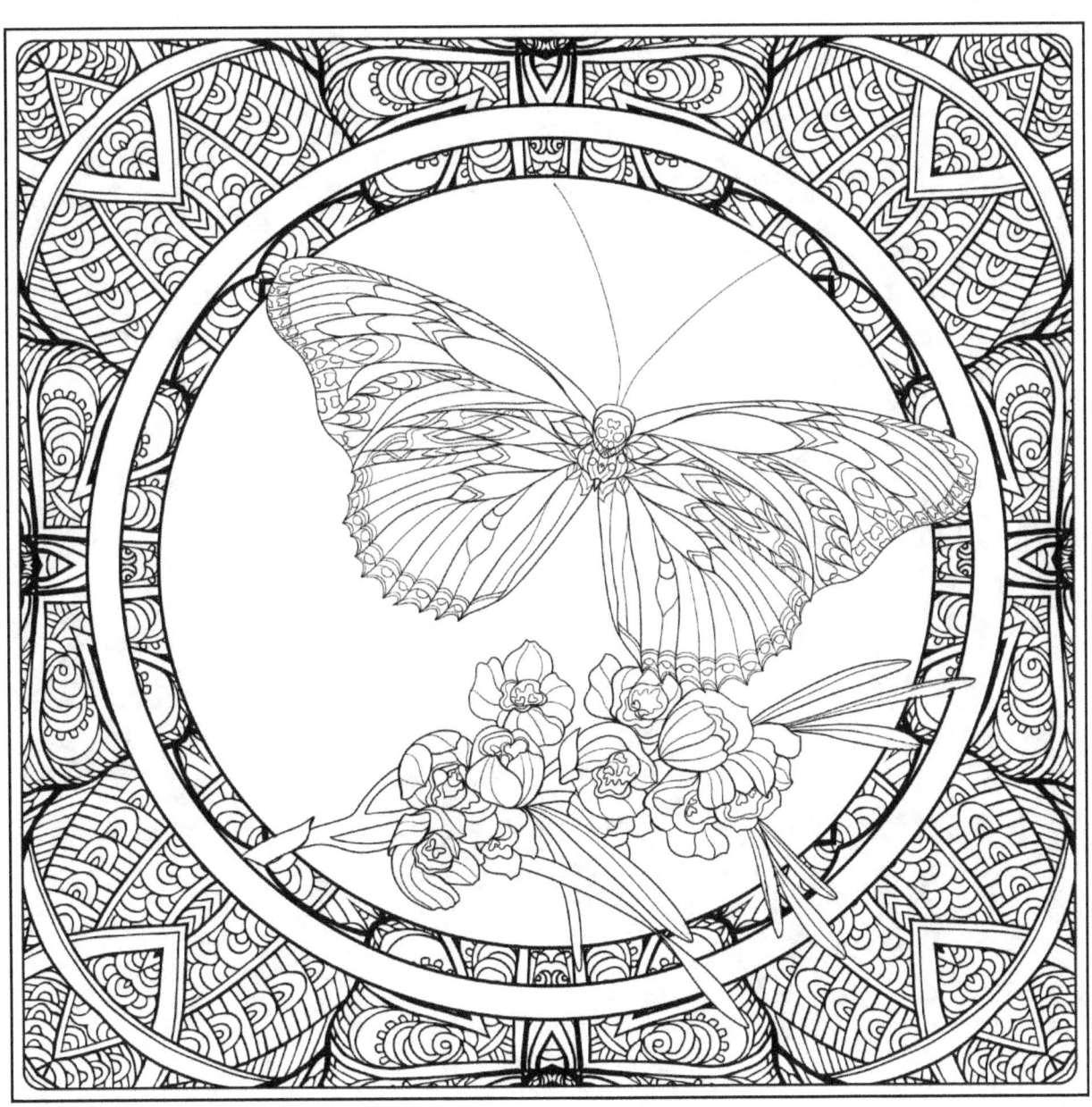

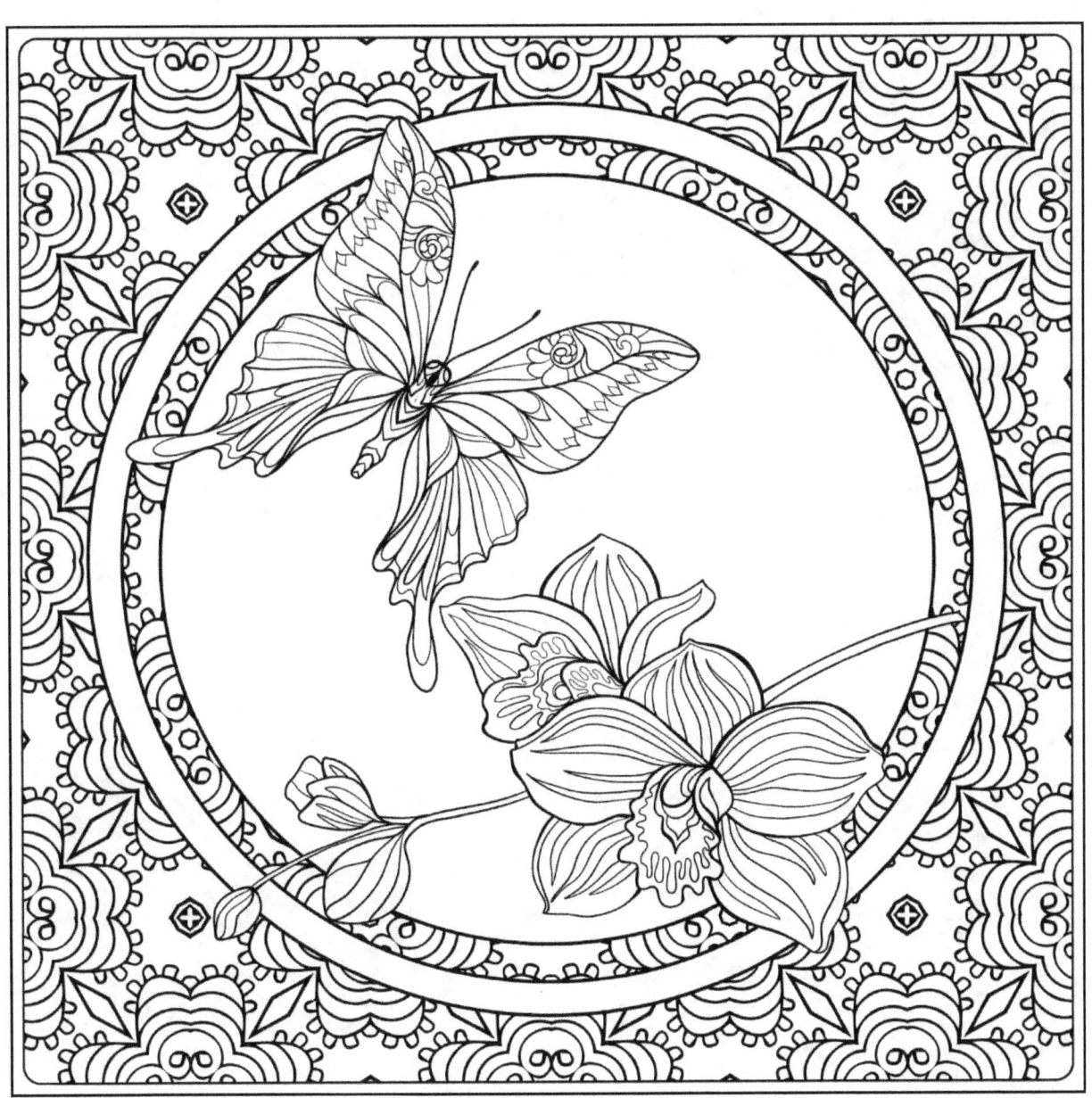

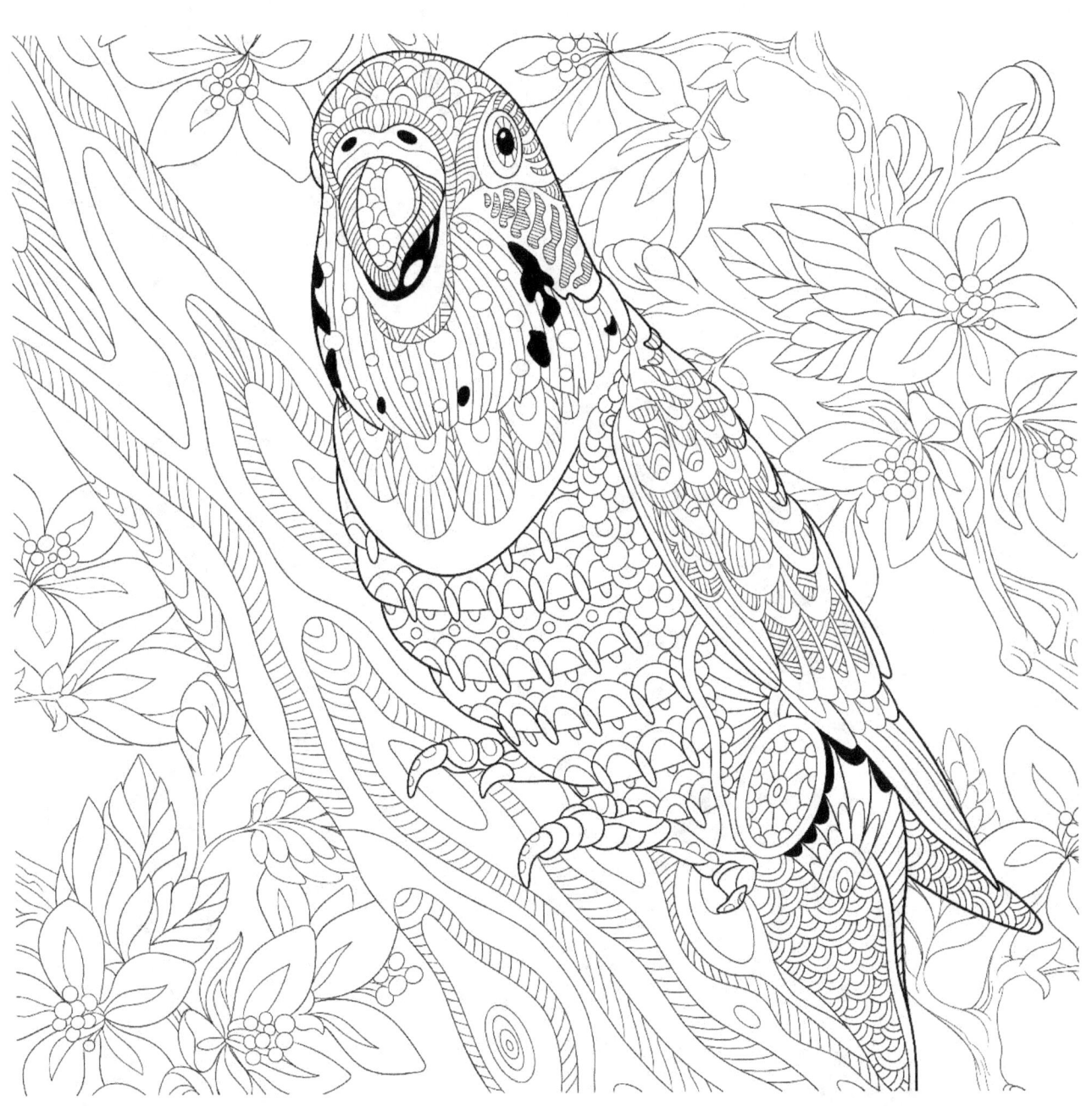

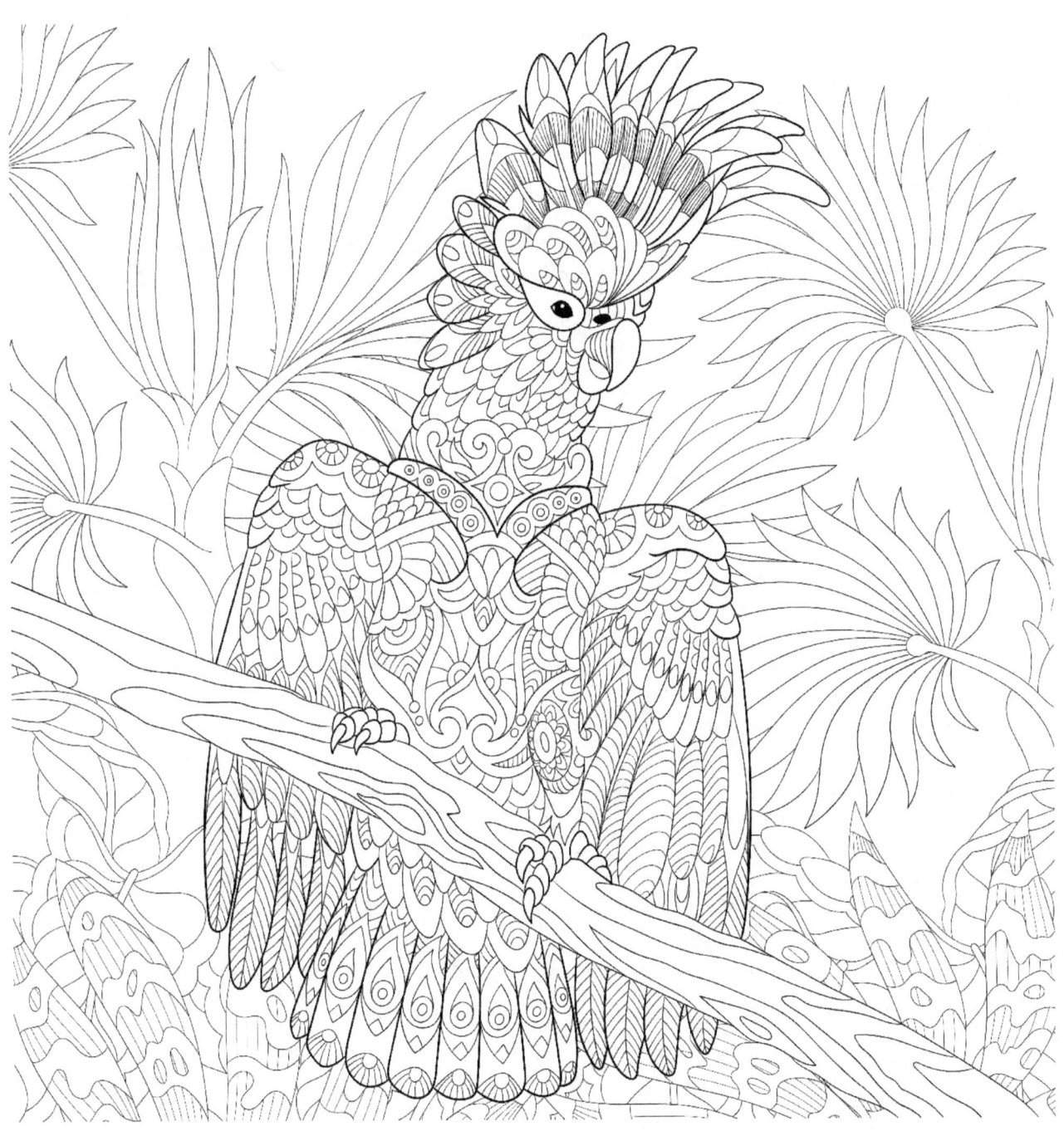

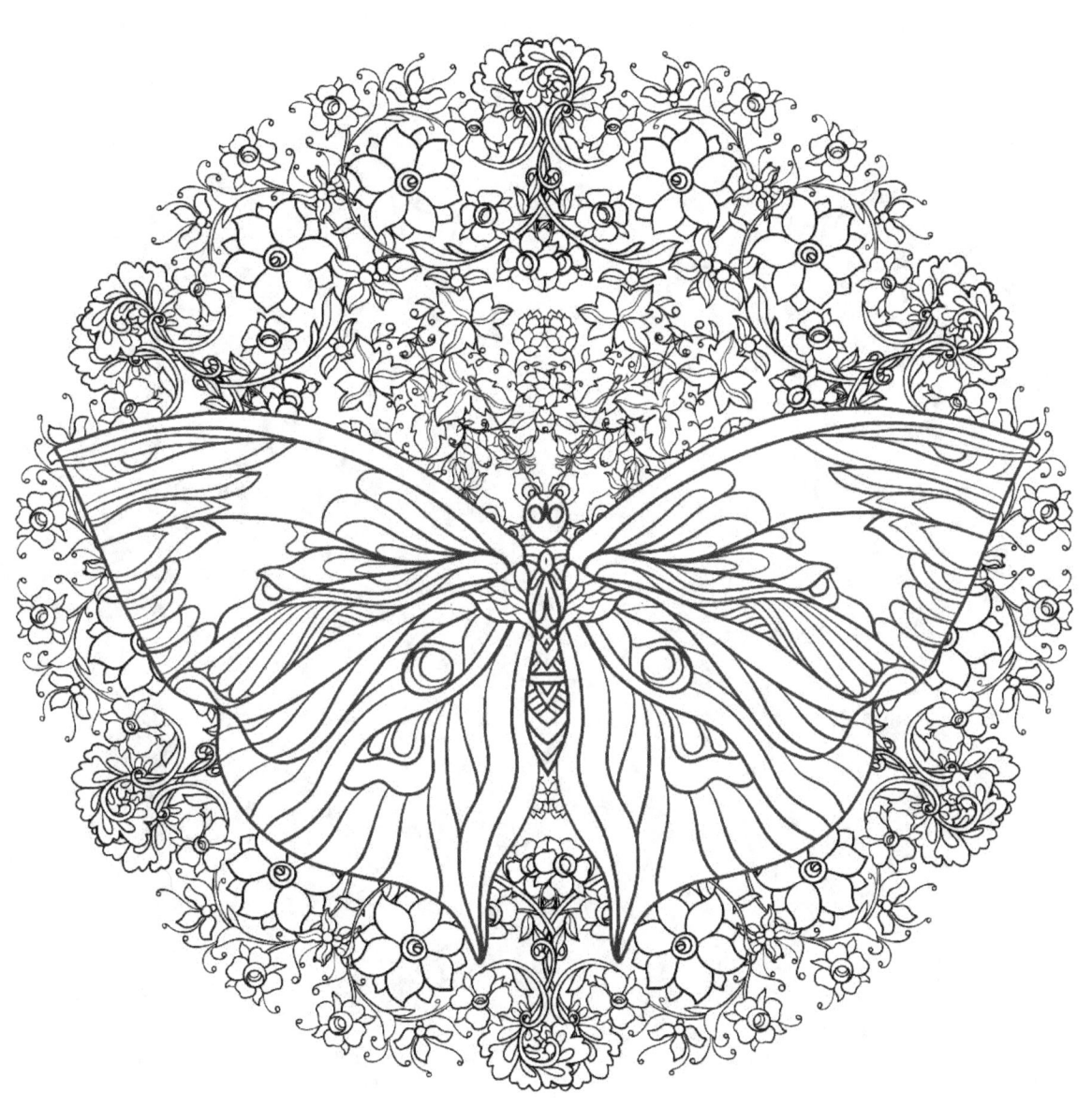

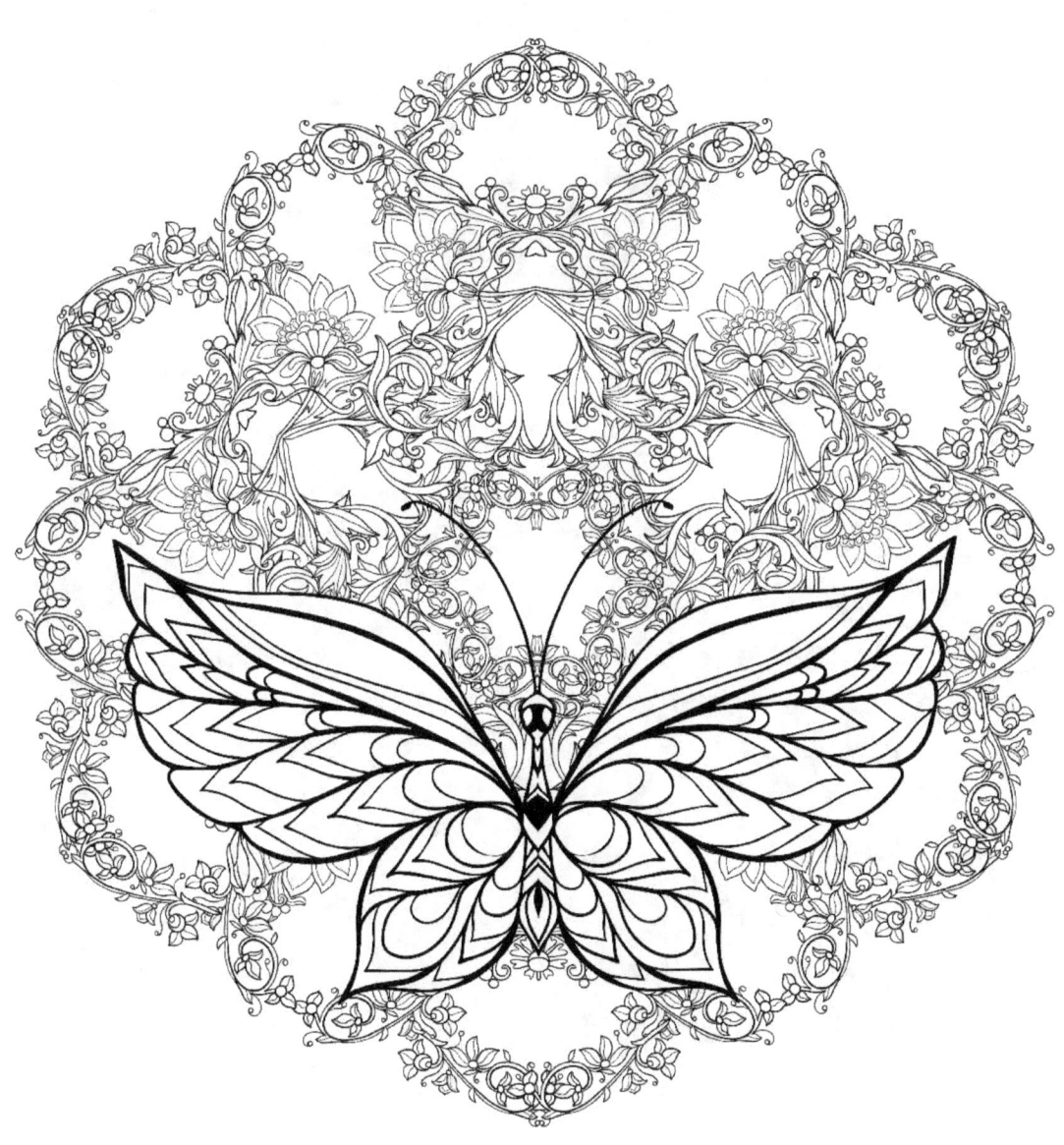

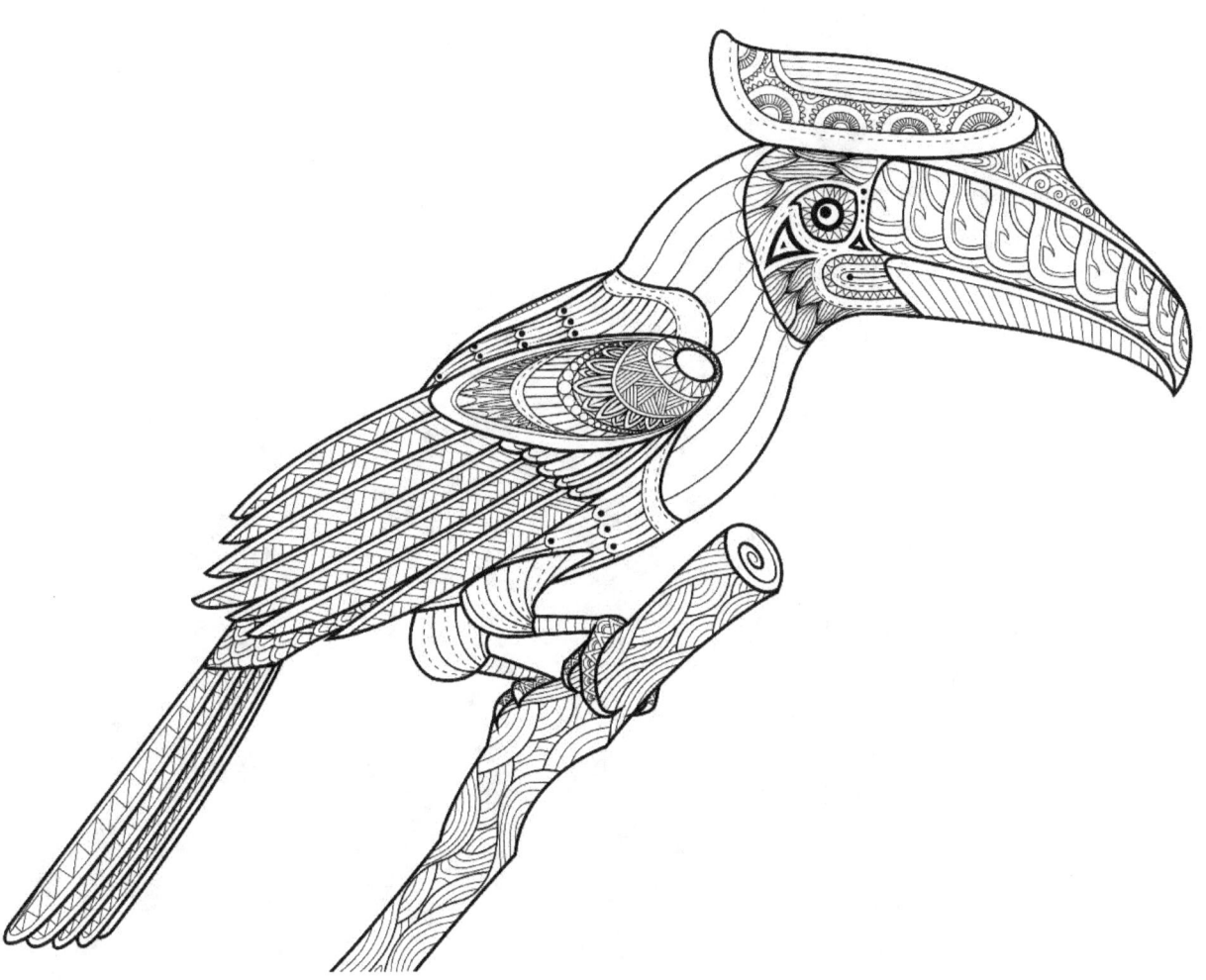

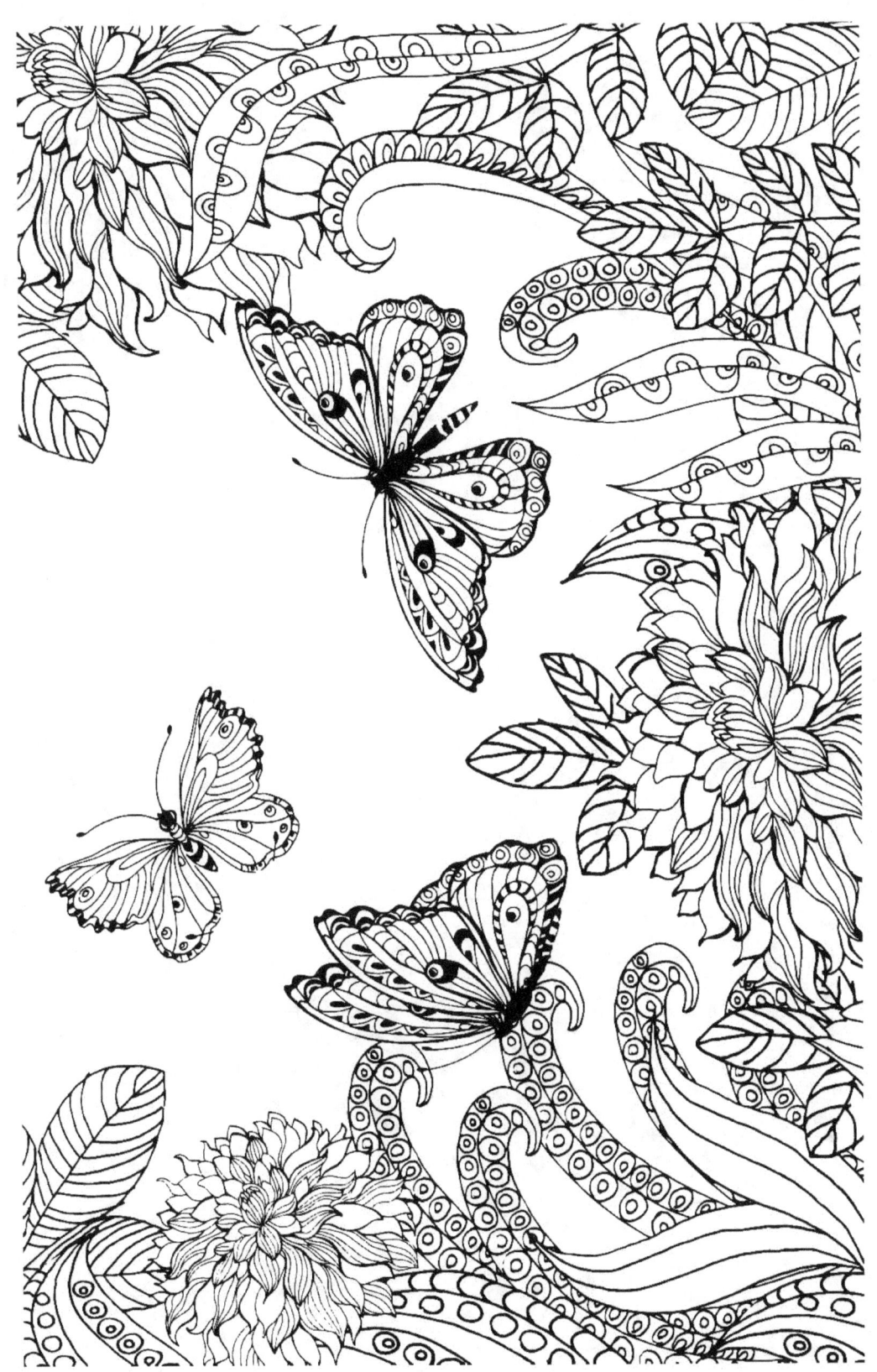

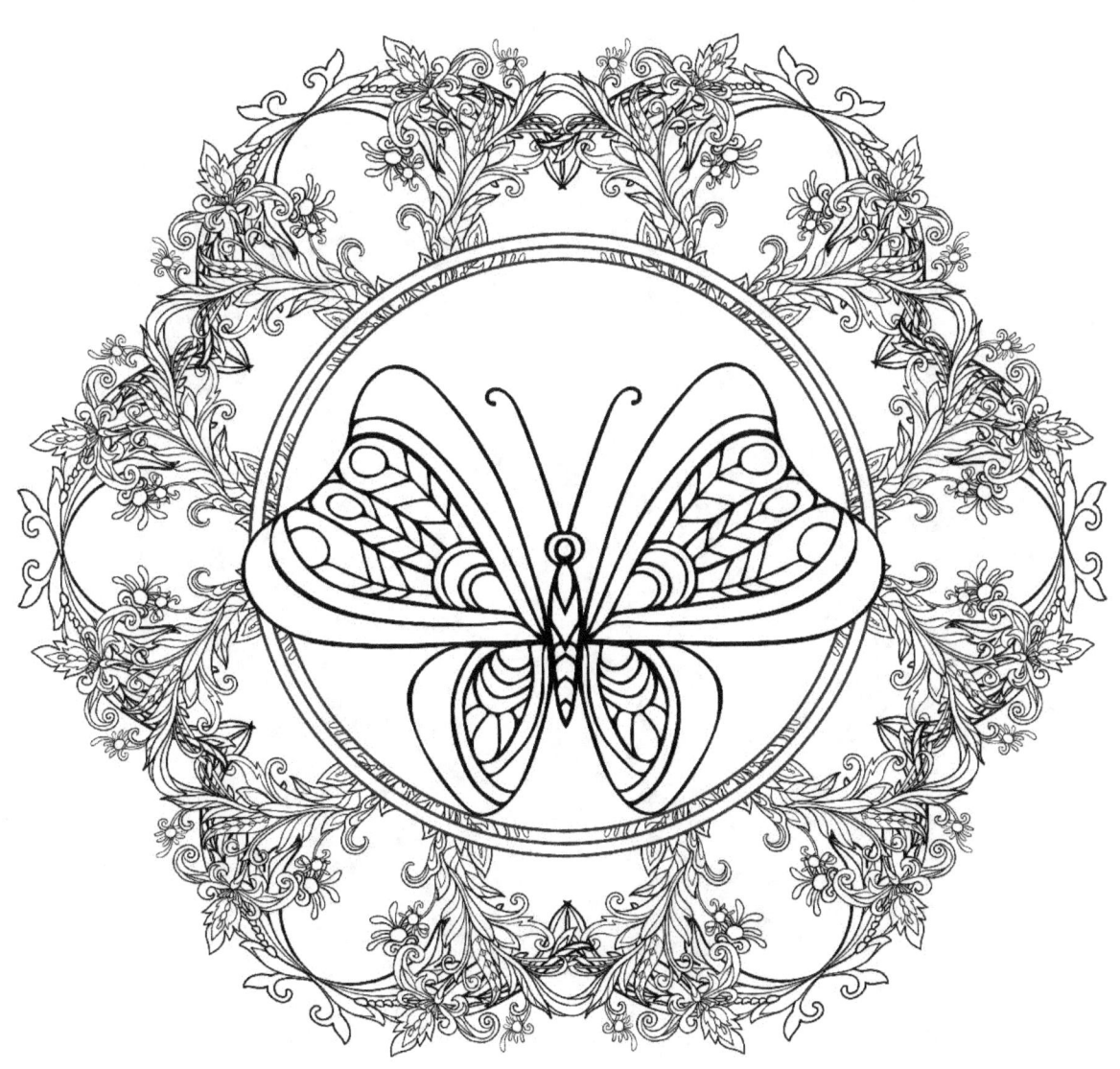

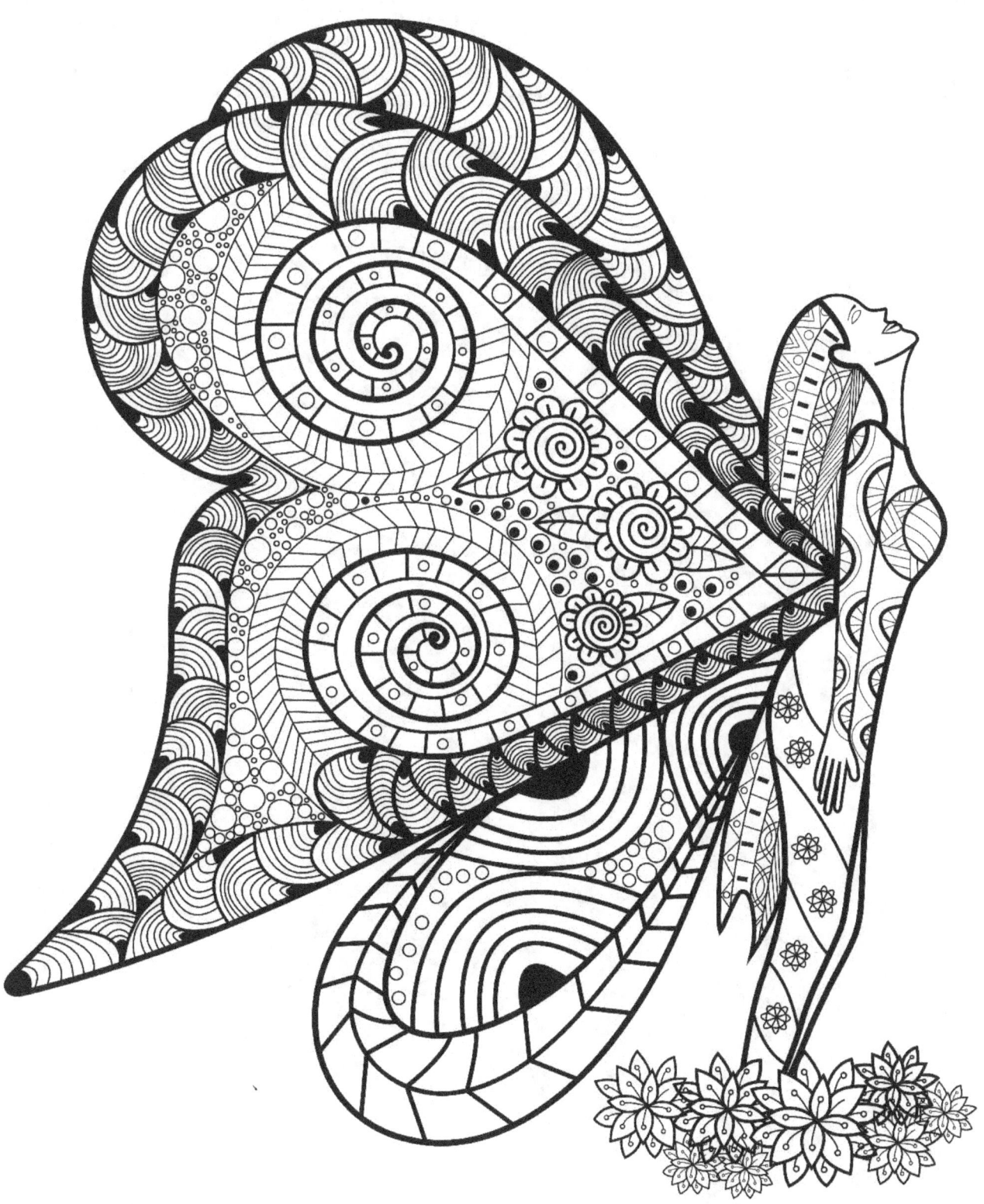

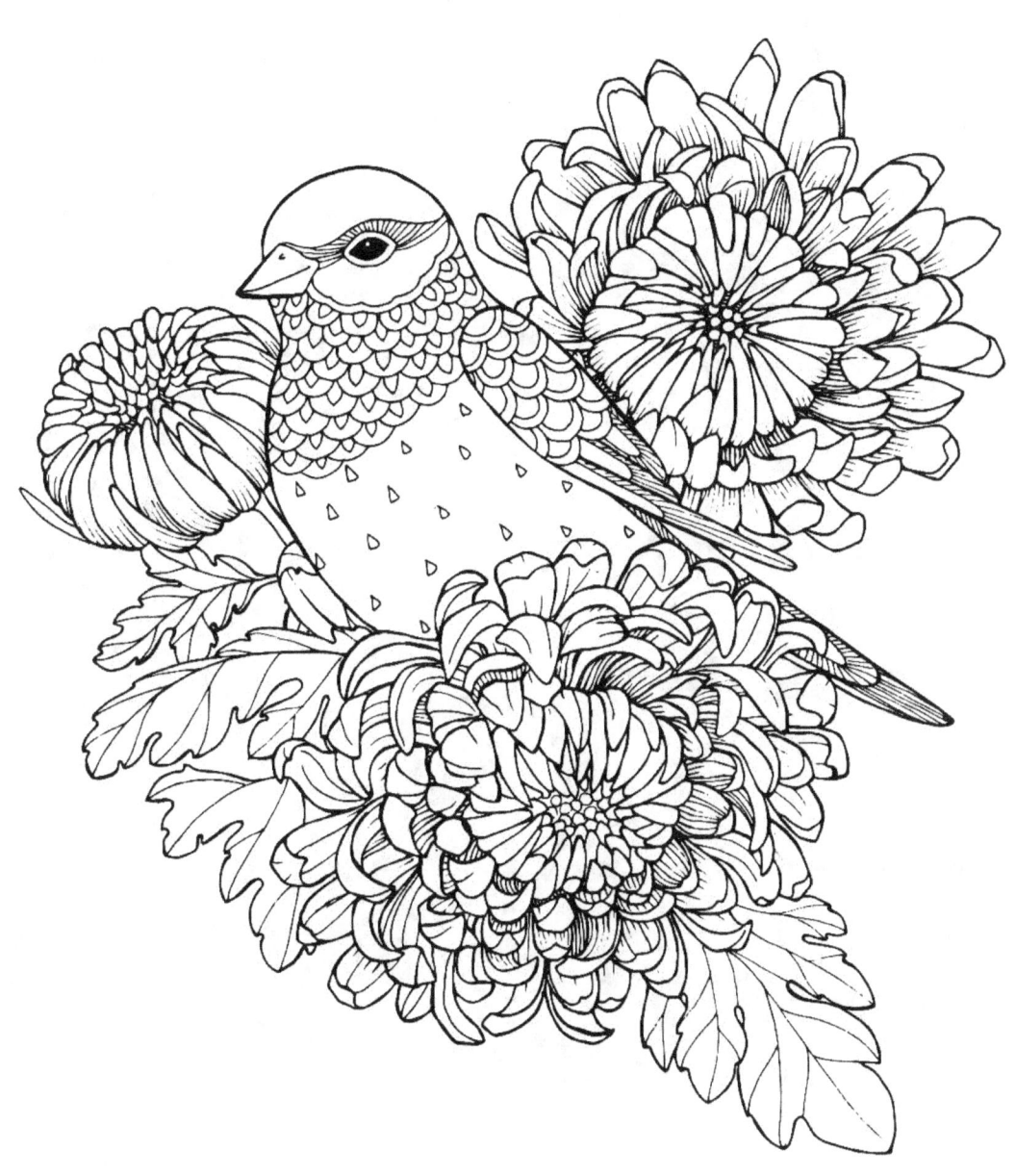

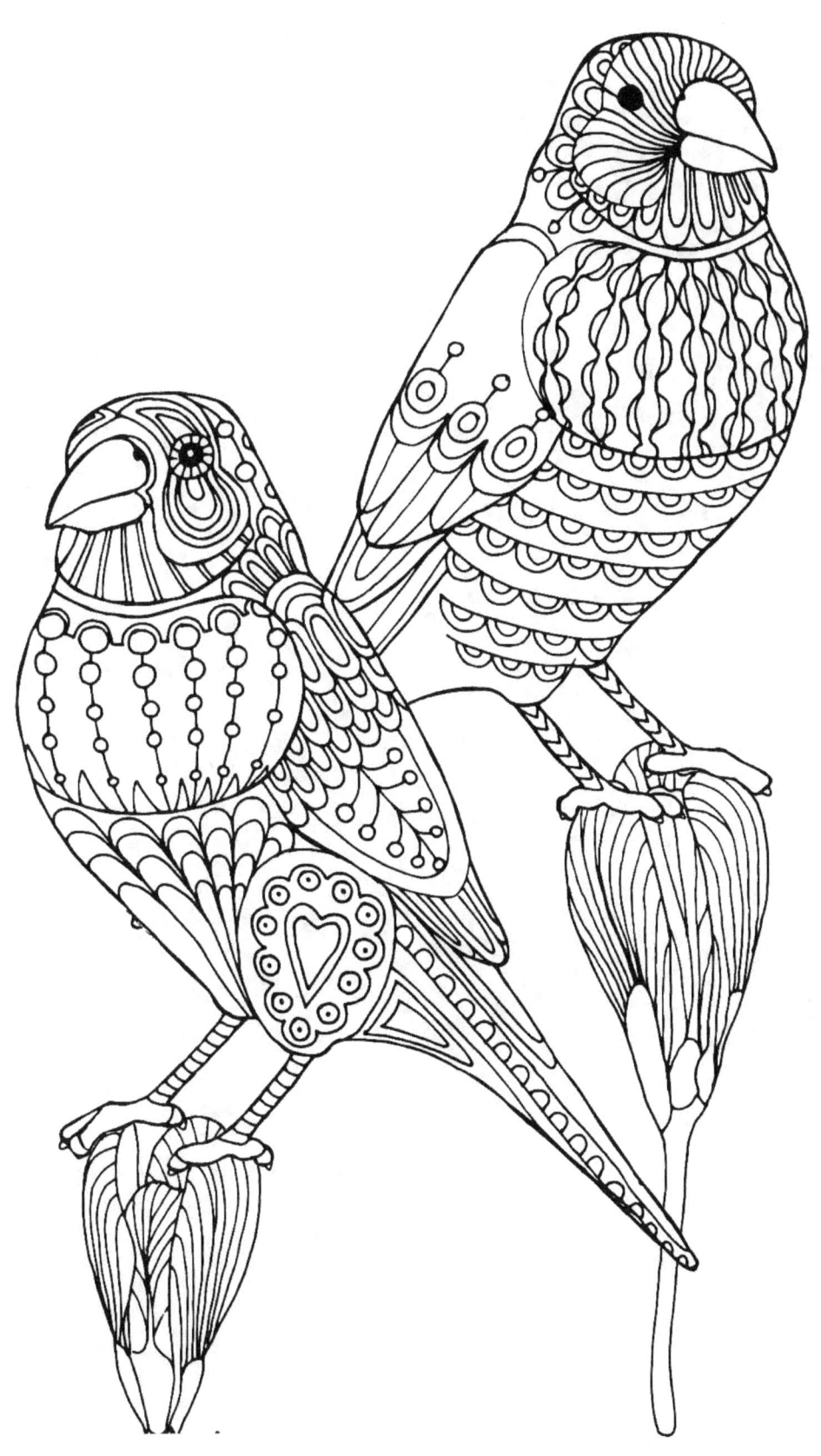

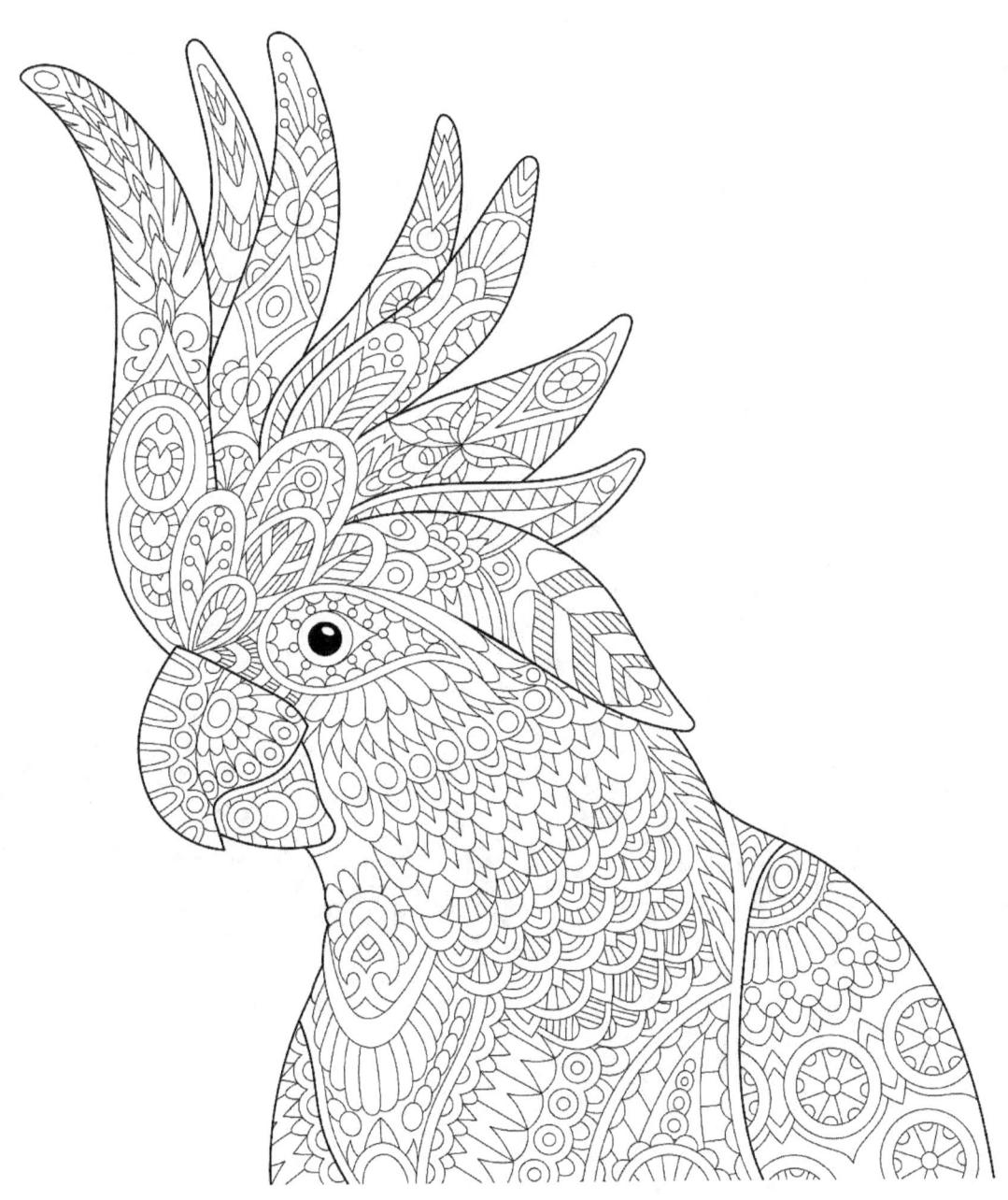

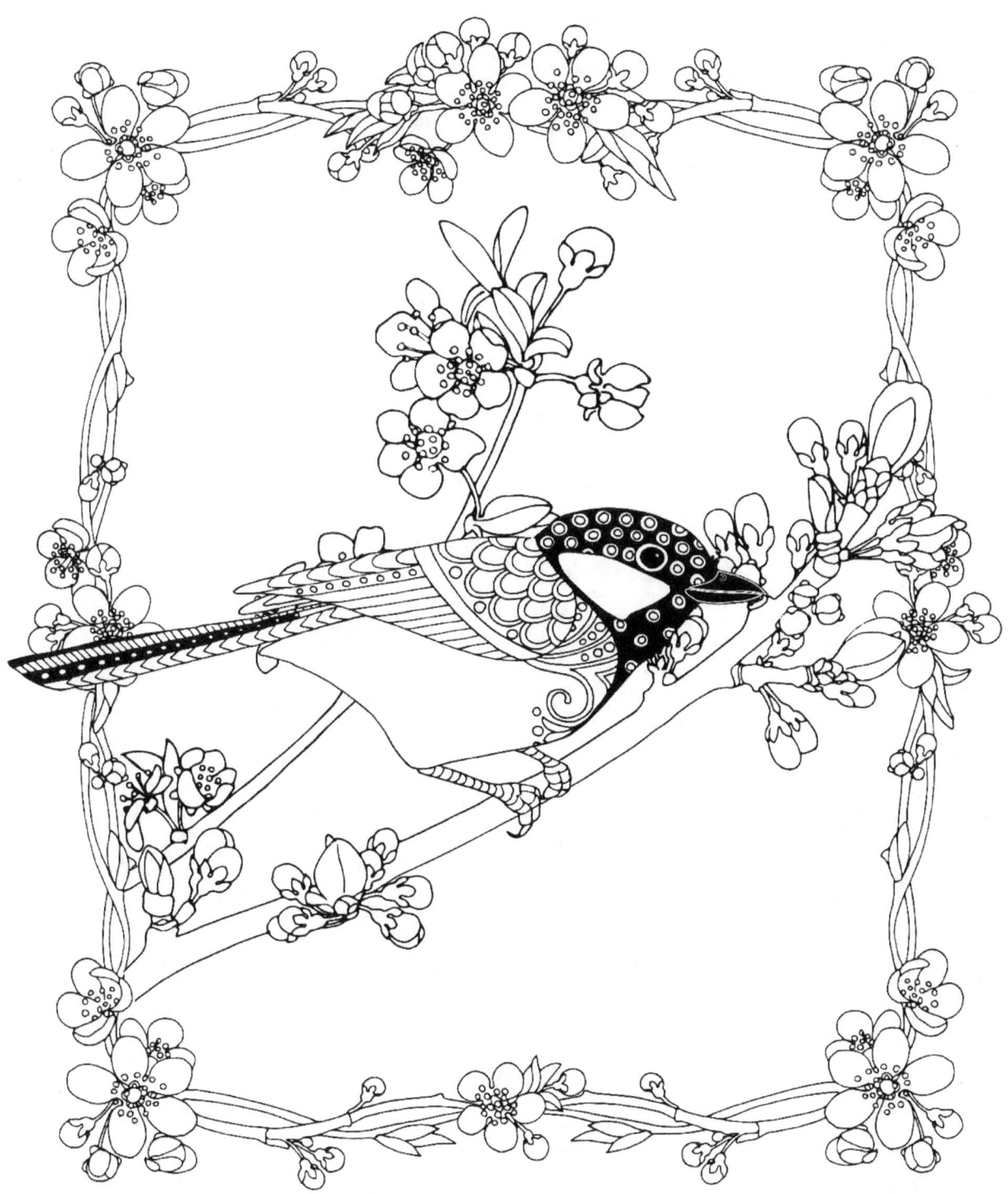

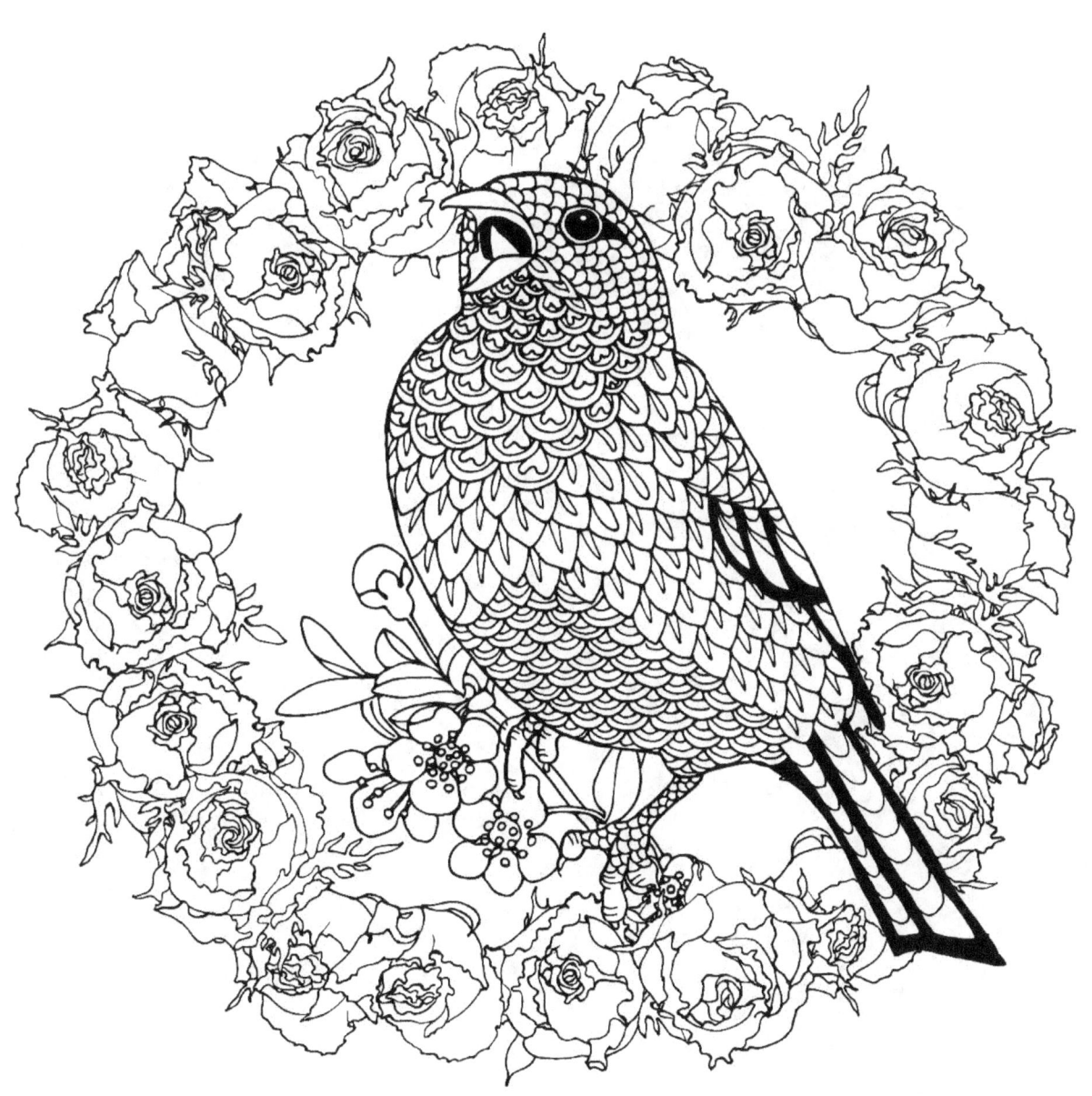

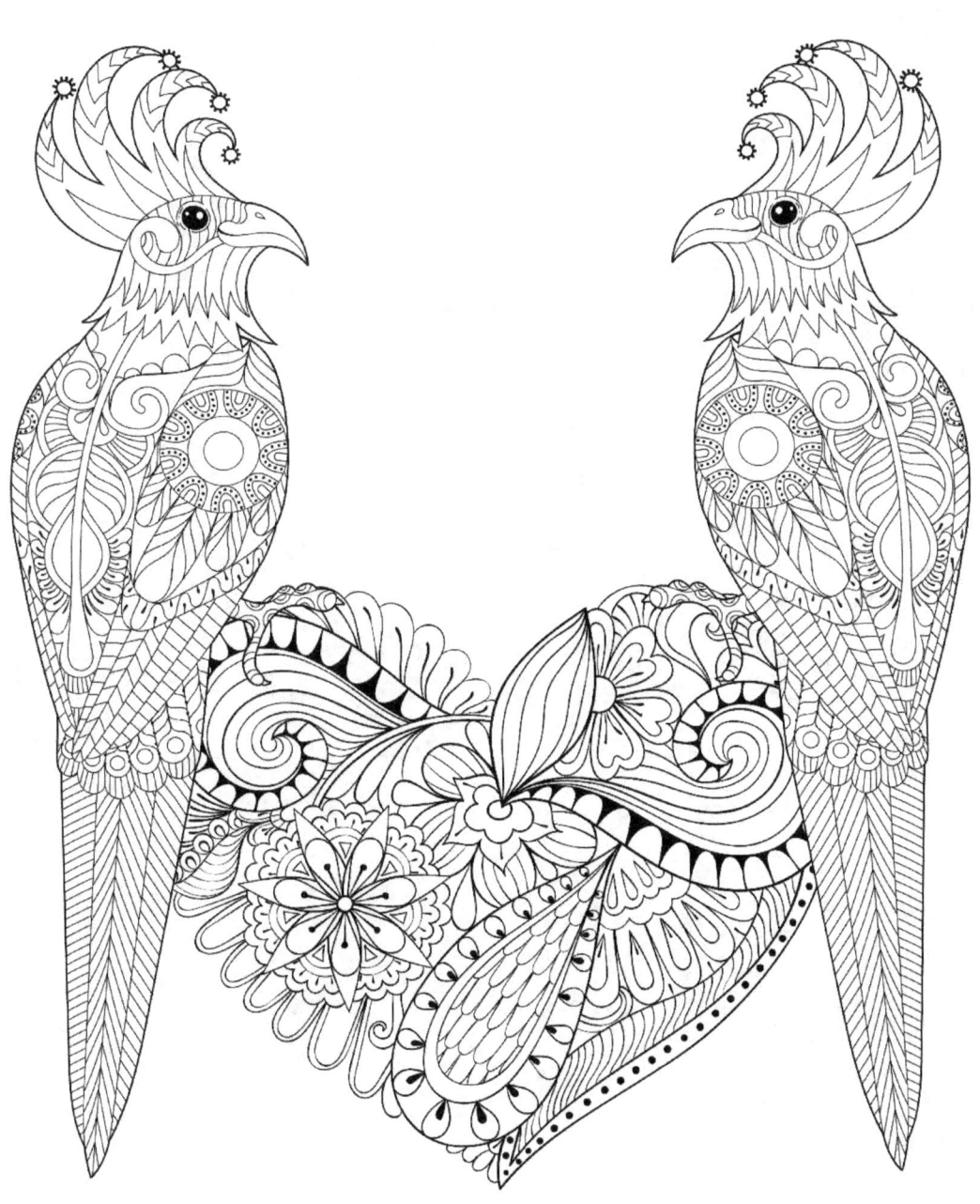

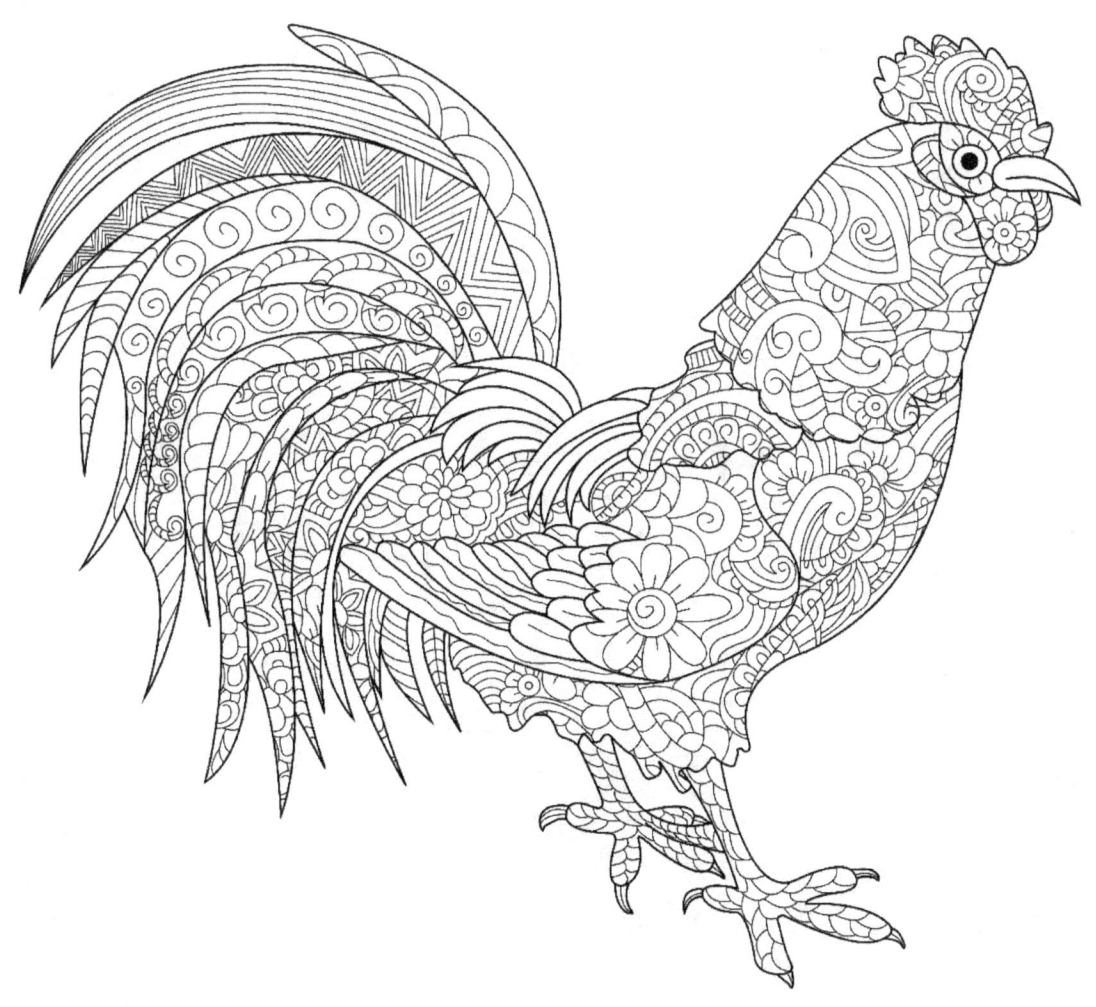

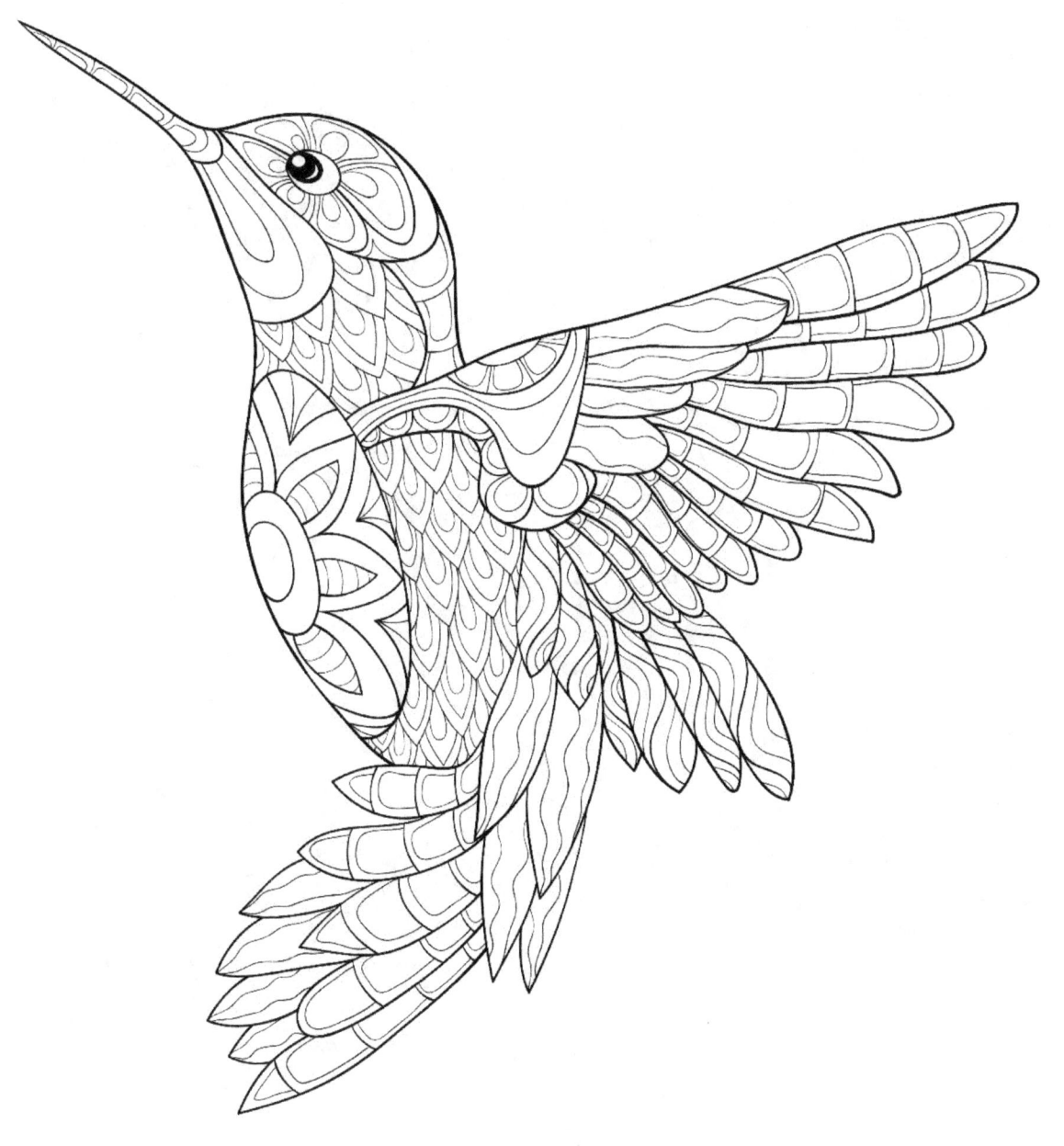

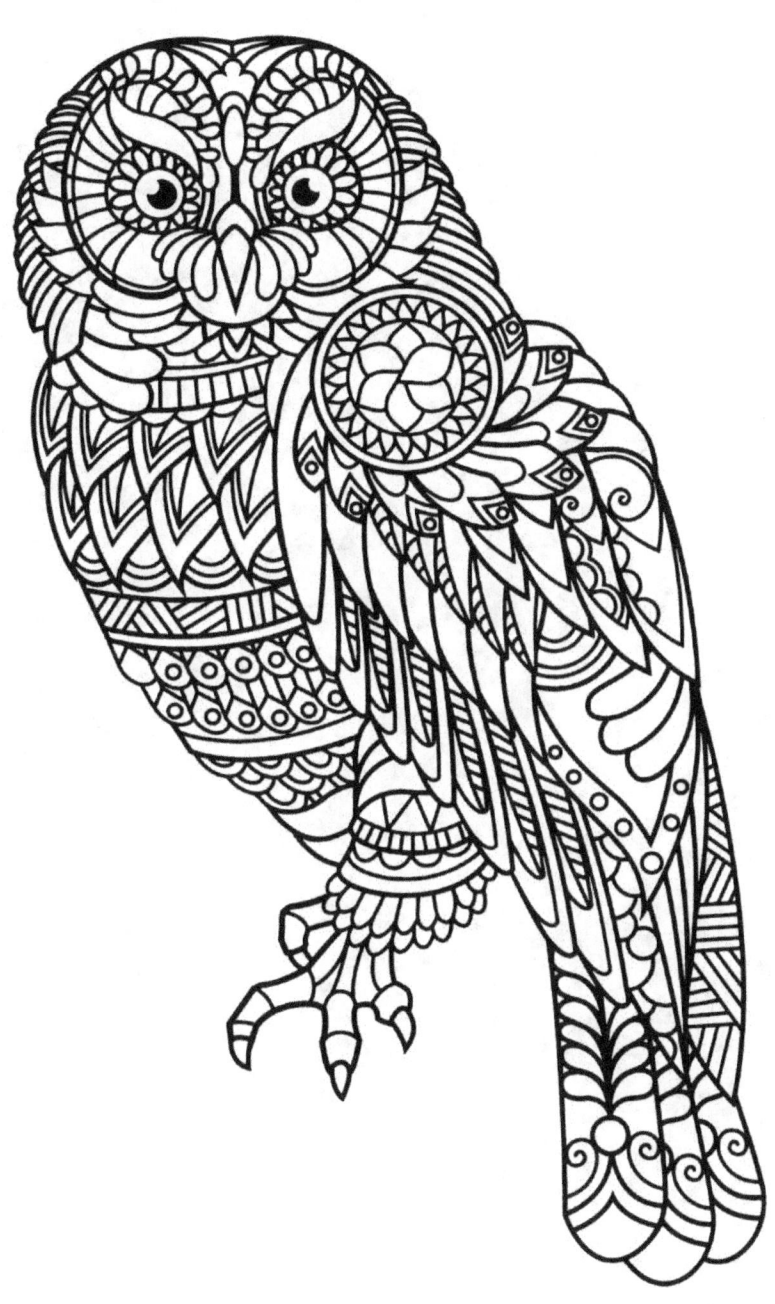

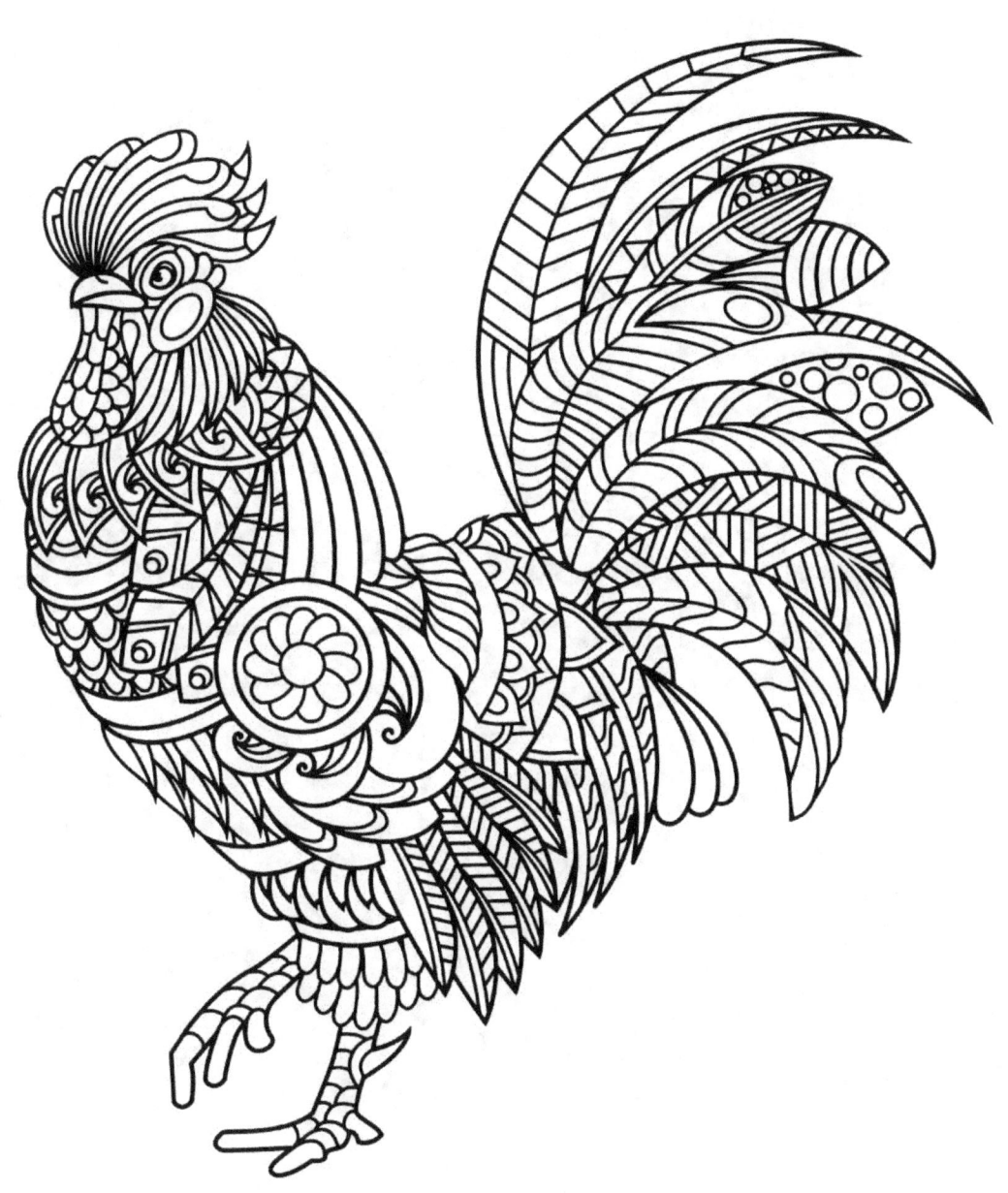

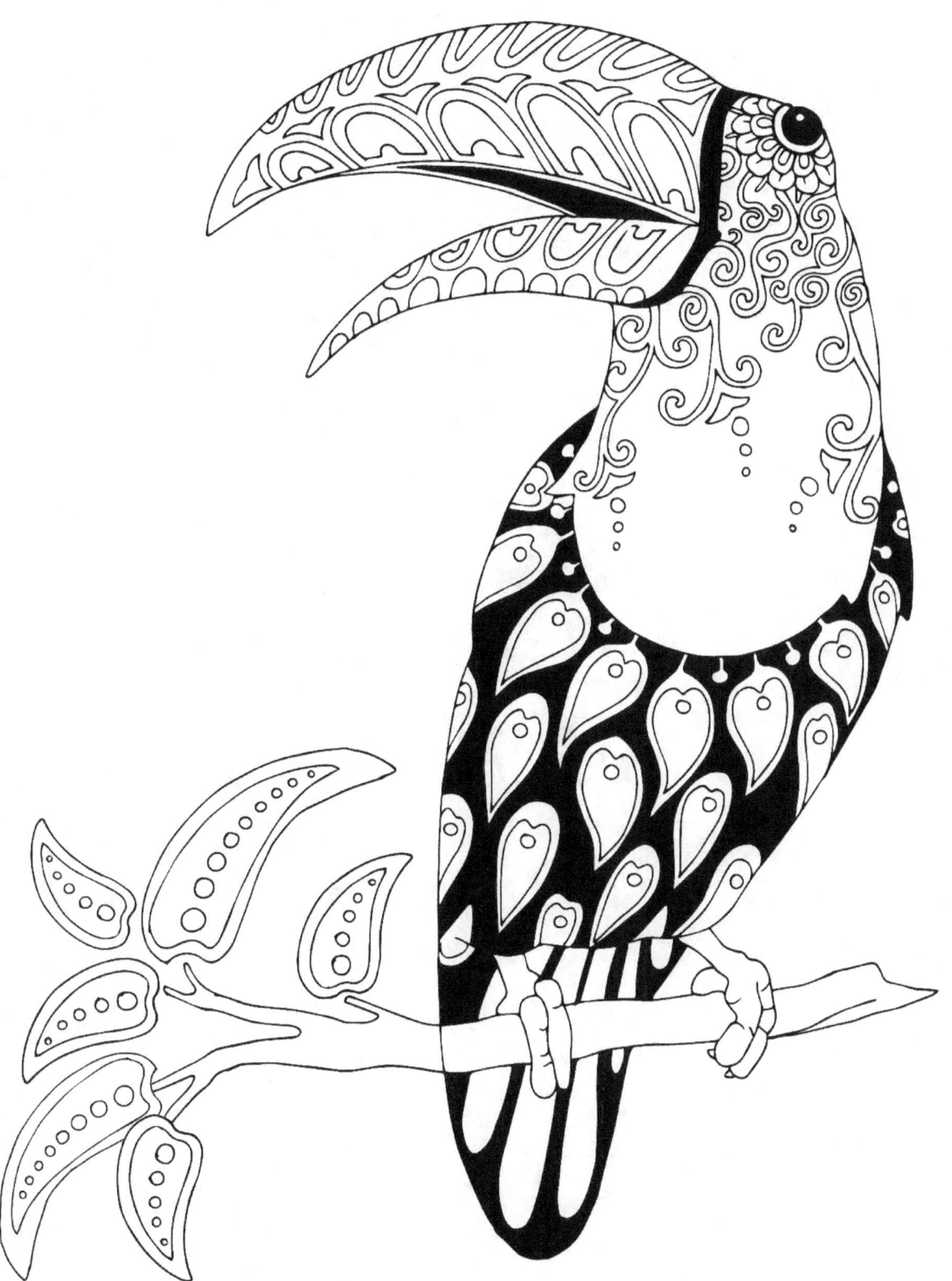

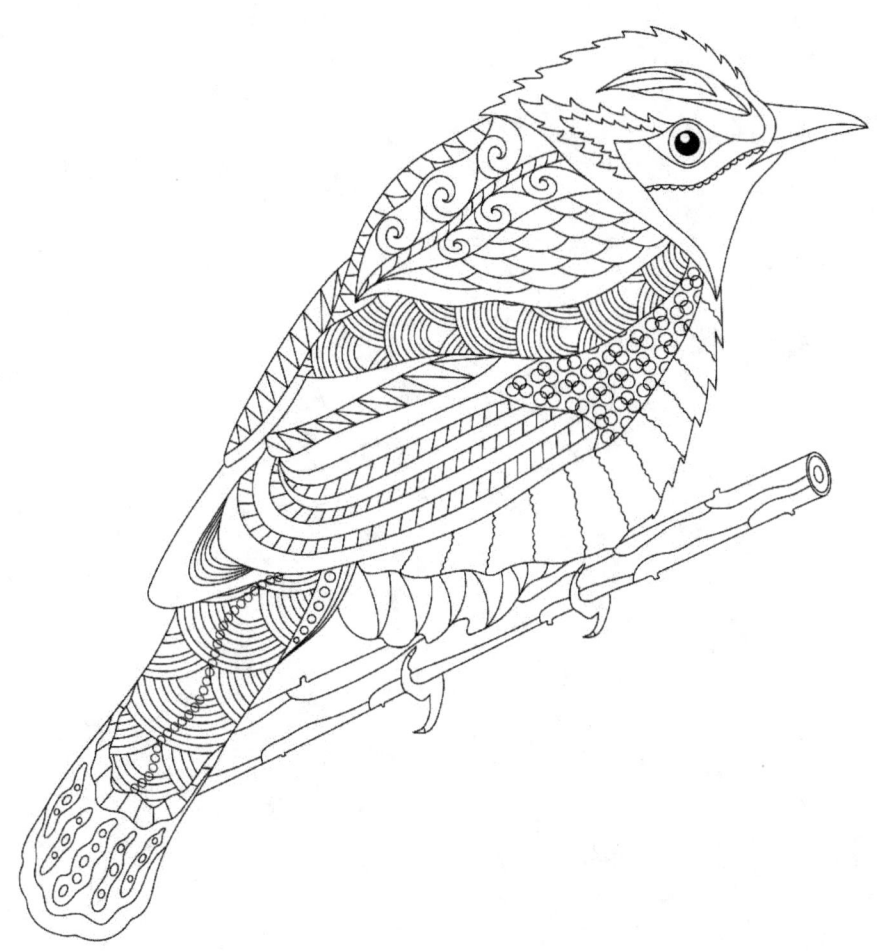

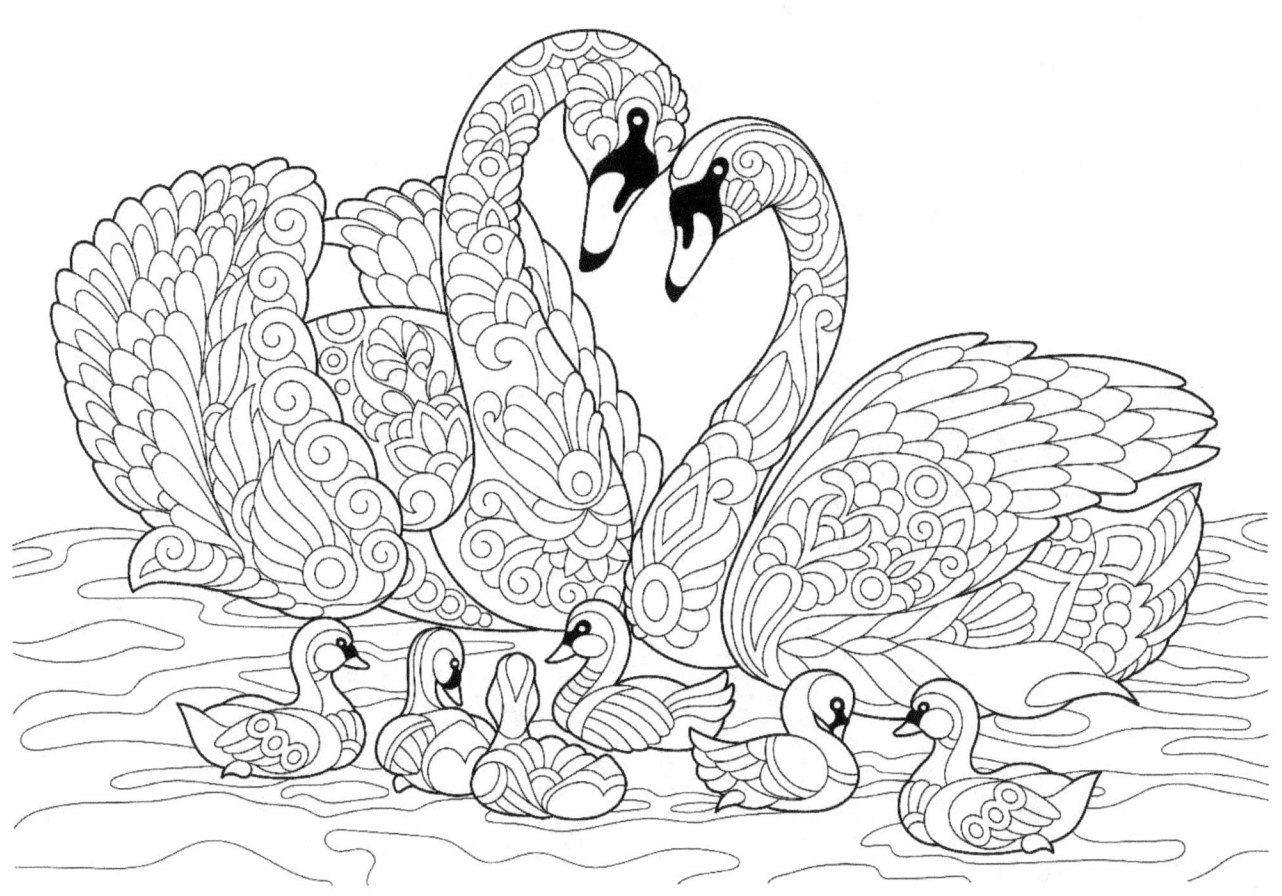

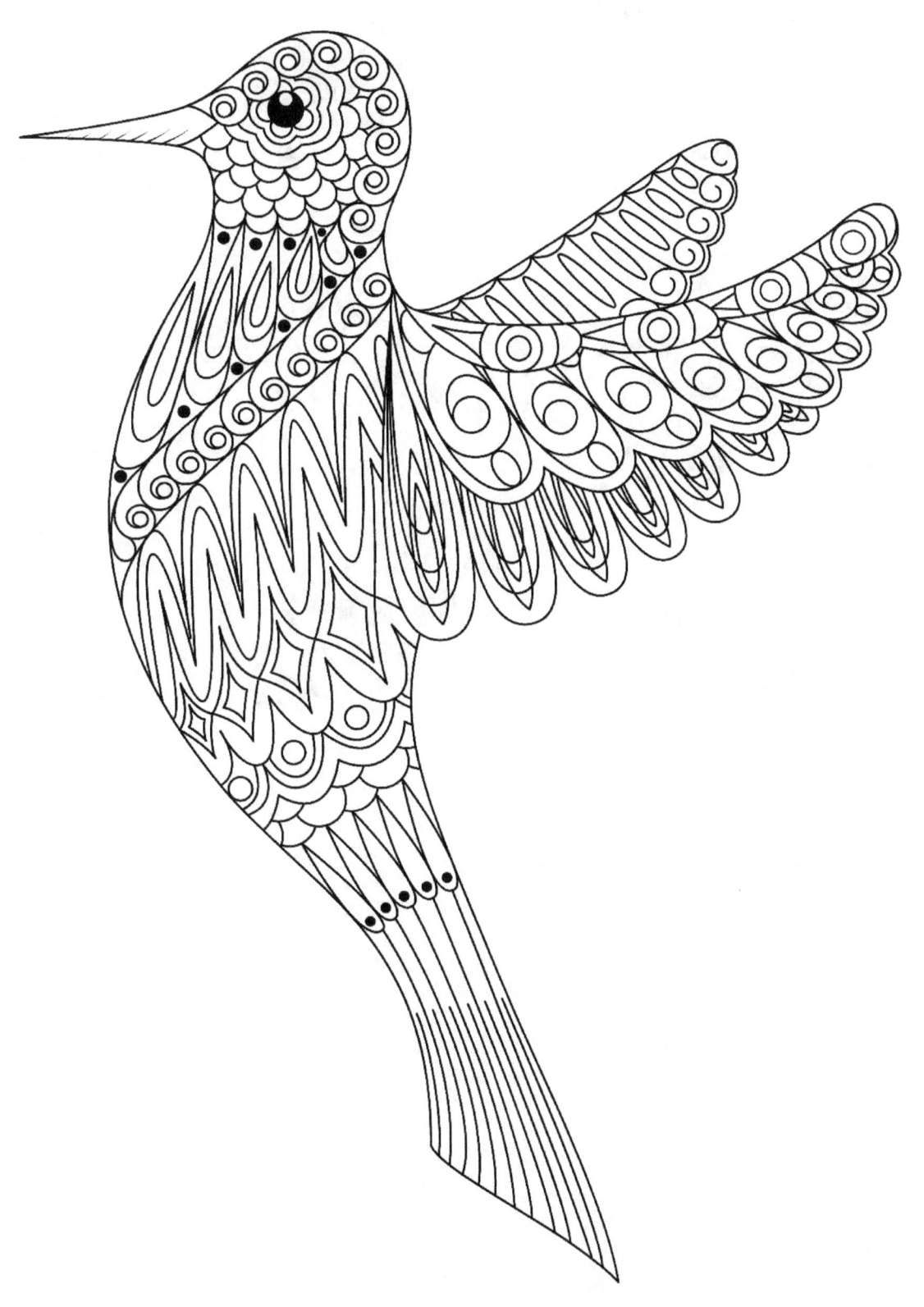

About the author:

Lamees Alhassar is a prolific, inspirational writer, artist & a humanitarian.

You can visit her website
http://www.lameesonline.com

and you can send her an email
Lamees.a@outlook.com

www.ingramcontent.com/pod-product-compliance
Lightning Source LLC
Chambersburg PA
CBHW080559220526
45466CB00010B/3196